Sit!

The Dog Portraits of Thierry Poncelet

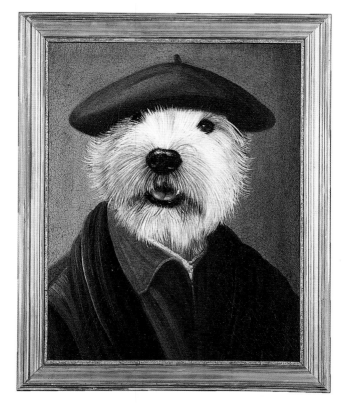

Paintings by Thierry Poncelet
Text by Bruce McCall

Stephanie Hoppen Gallery
Workman Publishing, New York

Library of Congress Cataloging-in-Publication Data

Poncelet, Thierry.
Sit!: the dog portraits of Thierry Poncelet.
p.cm.

ISBN 1-56305-380-2

[1. Portraits—Caricatures and cartoons.
2. Wit and humor, pictorial. I. Title.]
NC1559.P66A4 1993
759.9493-dc20 93-21619 CIP

Stephanie Hoppen Gallery
Workman Publishing

Photographs of Thierry Poncelet's paintings in SIT!
were taken by the following:

Speltdoorn
Pages 19, 20, 23, 29, 35, 67, 76.

Michael Hoppen
Pages 25, 34, 58.

All other photographs were taken by Roy Fox.

*Wallpaper backgrounds kindly supplied by Christopher Hyland Inc.
and Arthur Sanderson & Sons. Computer Graphics by Virginia S. Dustin*

Workman Books are available at special discounts when purchased in bulk for premiums and
sales promotions, as well as for fundraising or educational use. Special editions can also be
created to specification. For details, contact the Special Sales Director at the address below.

Workman Publishing Company, Inc.
708 Broadway
New York, NY 10003

Printed in Hong Kong

First printing October 1993

10 9 8 7 6 5 4 3 2

Contents

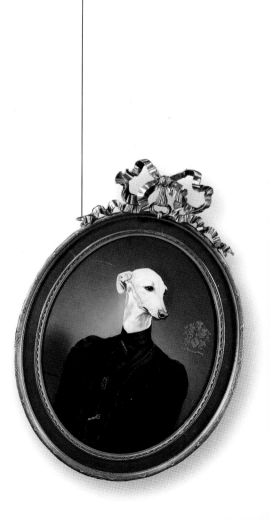

About the Artist

.

"I love dogs. I grew up with three cocker spaniels. I know how to talk with dogs. I can just feel what they're like, which is why I can attribute genuine human sentiments to them. This makes it easy to imagine them dressed up in costumes." —THIERRY PONCELET

"My dog portraits are a combination of my two most favorite things in the world—ancestral portraits, which I collect, and dogs," says Thierry Poncelet, a Belgian artist and art restorer. Poncelet's witty transformations begin with an actual nineteenth-century portrait that he hunts down at flea markets, antique shops or estate sales. He restores the painting brushstroke by brushstroke, then seamlessly paints in a dog's head over the original sitter's. He admits that sometimes, working alone, he doubles up with laughter at that magic moment when the features of the ancestor seem to dissolve into those of the animal.

The first "aristochien", as he calls his portraits, came about when Poncelet was repairing an antique portrait for an art dealer. Tired of restoring and bored by the human face, he substituted his own dog's head—a golden cocker—for the lady's. When the dealer saw it, instead of being outraged, he commissioned more. Since then Poncelet's exhibitions in Milan, Paris, London, and New York have delighted the art and dog worlds.

Poncelet has a genius for matching the right breed and canine expression with the perfect surrogate body. "Sometimes it's the physical appearance that inspires me, sometimes the psychological affinity," he says. His dogs do seem to embody human personalities—whether transformed into prim Victorian spinsters or raffish military officers. In the *SIT!* gallery we have seventy of his best portraits—a kind of Dickensian panorama of nineteenth-century society, from grand dames to governesses, tycoons to courtesans.

Besides revealing something about society, Poncelet has found the perfect vocabulary to talk about the nature of dogs—whether it's the prideful beauty of a whippet (Duchess Pavlovna), the fussbudget soul of a Pekingese (Countess Eugenie), or the shrill self-importance of an Irish setter (Judge Obsidian Smuckles).

Though some perceive his work as social satire, Poncelet claims he is only having a good joke. "I think when I put a fine-looking animal into a picture, I'm improving the composition," he says mischievously. "This is Poncelet's true magic," says his gallery owner, Stephanie Hoppen, "he does not mock humans, but gives his dogs humanity." See for yourself.

Artists & Aesthetes

Solange

She was cast out by her family and raised by gypsies. She was the cause of six suicides and a scandal in a Trappist monastery by age fourteen, and exiled to Morocco the following year for endangering the morals of the French Foreign Legion. All this and more was Solange, *danseuse extraordinaire*. "She is smoke from a cigar," wrote Diaghilev. "She is the swamp gas rising off the Sudd in darkest Africa. She is something." She was also prone to fishwife tantrums if the bourbon failed to arrive on her dressing-room table and threw lit matches into the orchestra pit if the rhythm was wrong. Her untimely demise—under a falling sandbag at le Théâtre du Spectacle in Marseilles—crushed the career of a legend who had, perhaps, endeared herself less to the stage managers behind her than to the connoisseurs of terpsichore before her.

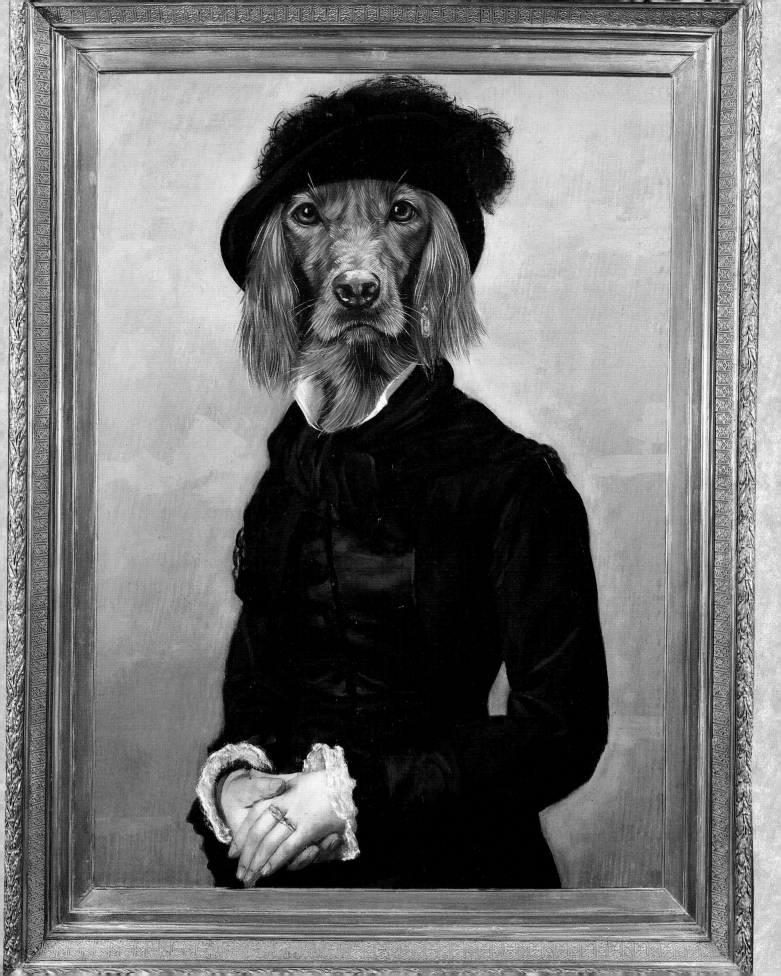

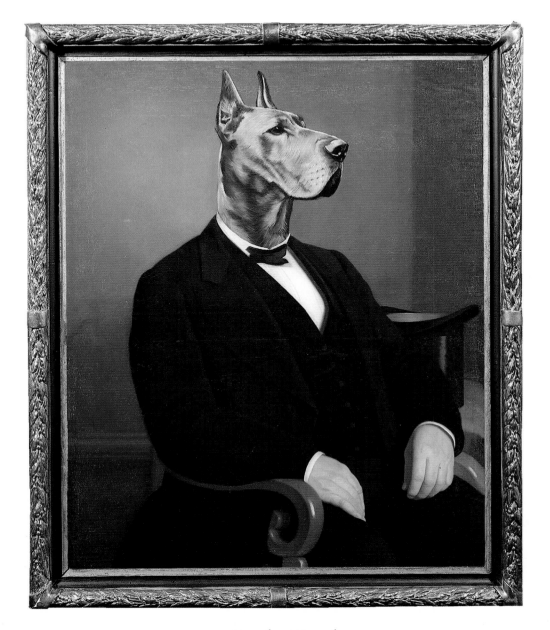

Lars-Hamlet Knudsen

Everything about this great Dane was noble: his breeding, his countenance, his jaw. A sculpting prodigy who began brashly refashioning table legs and carpets into fantastic new shapes even before he had been weaned, Knudsen in maturity would assert, "There is no material, no thing, that I have not instinctively lusted to cut and carve and worry into something astonishing to behold." It is testimony to his almost savage artistry that by career's end, Knudsen had altered—almost beyond recognition—the world in which he lived.

Emma Horsely-Hackett

Born to mercantile prosperity, Emma Horsely-Hackett received a pecuniary dowry from her dying father, whose only request was that she be frugal and fruitful. Eschewing her promises, she remained a spinster so as to dance *en pointe*. But an afflicted gourmande, Miss Horsely-Hackett soon found that excess *avoirdupois* occluded her *plié* and made her tutu much too tight. By twenty-five, she was confined to the role of the oak tree in *The Nutcracker;* her career as a dancer had come to a standstill.

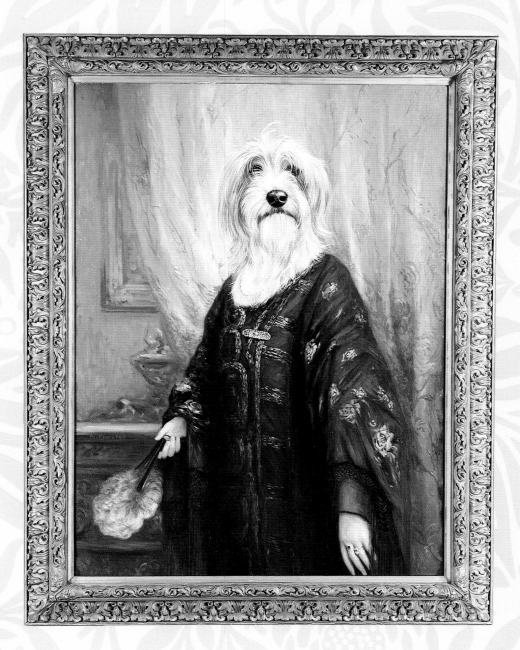

Per Jook van Klomp

The instant of his portrait's completion also marked a major shift in this prolific seventeenth-century Dutch master's painting career. Van Klomp lost his balance, the stool toppled backward, and the blow to his head seemed to affect his artistic outlook forever afterward. *The Dutch Scream* and the epic *Squirrel Massaging His Forehead*, so painful to contemplate even today, all date from van Klomp's post-pratfall period.

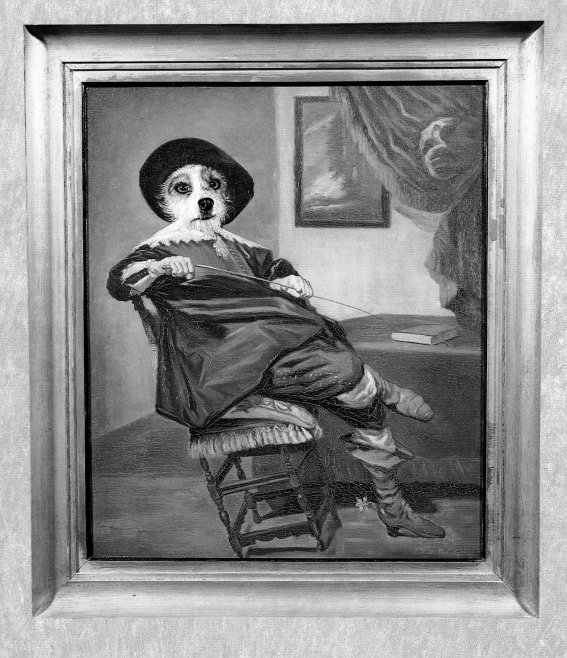

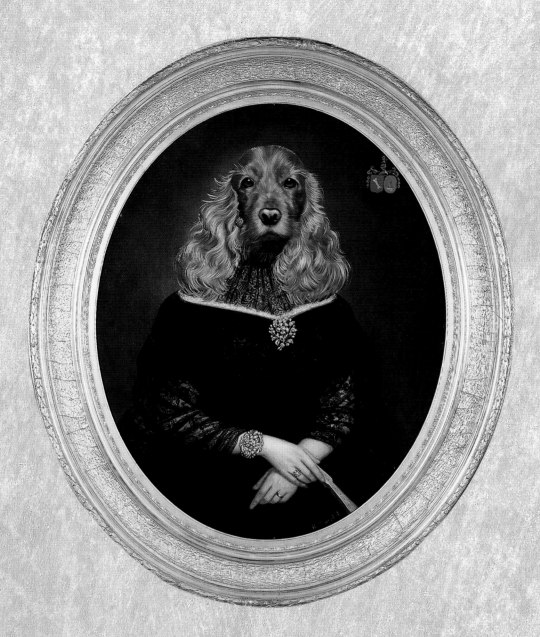

Birgit Bergstrom

The so-called Swedish Howitzer could shatter a bottle of aquavit from thirty meters away with her pure and penetrating soprano high note: indeed, that was what drove her from cabaret work and onto the concert stage. Her Stockholm debut—a piercing and powerful recital of Liebknech's lung-busting set piece, *The Milkmaid's Lament*—brought down not only the house but also, alas, the chandeliers. She was to find her only steady work in a Malmö pawnshop, singing at ring settings to determine if the stones were diamonds or glass.

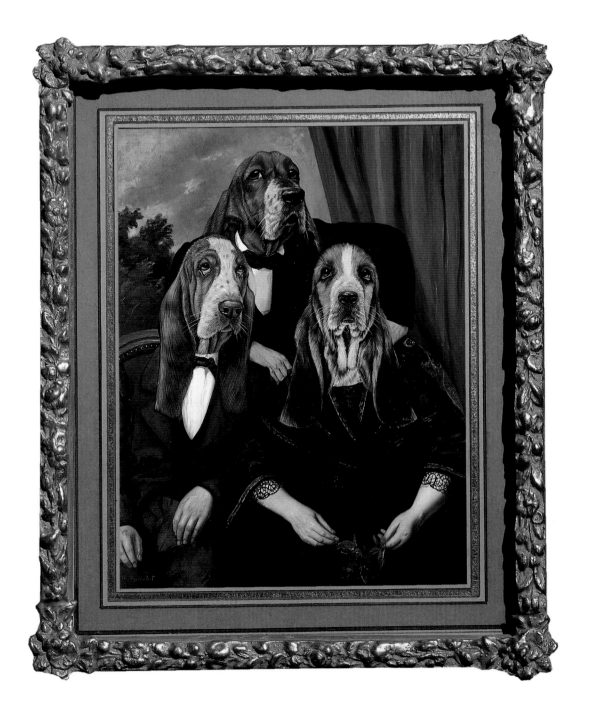

The Gilded Burymores

Europe's first (latter-day) theatrical family—sister Maude and brothers Basset and Lucien—quite curiously remained enjoined off stage as well as on, insisting that their thespian harmony owed as much to symbiotic domesticity as to good breeding. While none of them ever married, surprisingly few bones were made of Maude's disquieting false pregnancy—thought to have been induced by a roving stage hand.

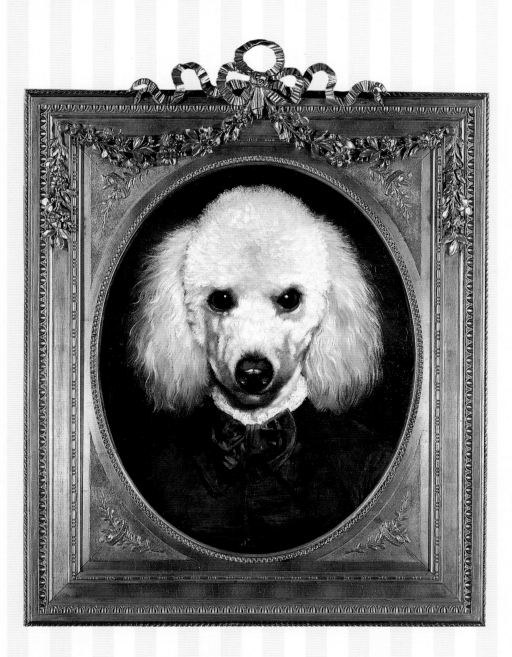

Marie-Claire DuBossy

The frank stare, the close-cropped coif, the air of dainty fastidiousness somehow at one with an implacable iron will—the Marie-Claire pictured here had changed not a whit from the vibrant young Marie-Claire who shocked France's poetry Establishment by refusing to beg. "Never will I teeter on my hind legs/And snivel for leftover scrambled eggs," began the opus that launched her career, "Nor roll over and play dead/For a scrap of Bébé Hortense's soft, wet bread." Because she demanded nothing less, Madame DuBossy received a deference, bordering on fealty, denied to creatures of less hauteur.

Sir Algernon Buncombe

The homesick seven-year-old who tunneled his way out of Eton with a dinner fork was perhaps predestined to become the King's landscaper, yet his vocation brought Sir Algernon scant joy. Prematurely jowly, rheumy-eyed and splayfooted, morose of mien, he was cut in court circles and found his companionship elsewhere. "It is well that he carries so formidable a Nose," observed Dr. Johnson, "for it helps him, never failing, to sniff out where the brandy is hid."

Le Vicomte de Dogerelle

Famed for having singlehandedly drafted the 278-point 1772 Treaty of Strasbourg, only to discover that nobody was at war and that he was actually in Lyon at the time, Le Vicomte possessed a mind simultaneously scalpel sharp and fog hazy. It was his Avian Code, a plan for regulating bird life—including a ban on the right of assembly for crows—which got him pensioned off from government service at the precocious age of thirty. The remainder of his days were spent writing poetry of such unique character that a certain school of verse is named after him.

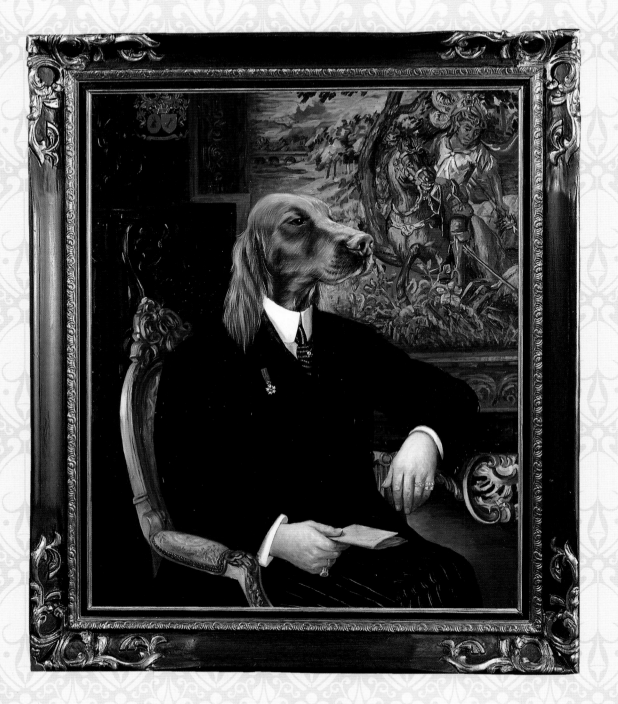

The Dancing Clumbards

It was sleek Carlo and slinky Carlene, those dancing Clumbards,
who introduced the Stroll and had all teatime London doing
the Step 'n' Fetch—and electrified His and Her Majesty at a command
performance with the bobbing syncopation of the Down Boy, Down Boy,

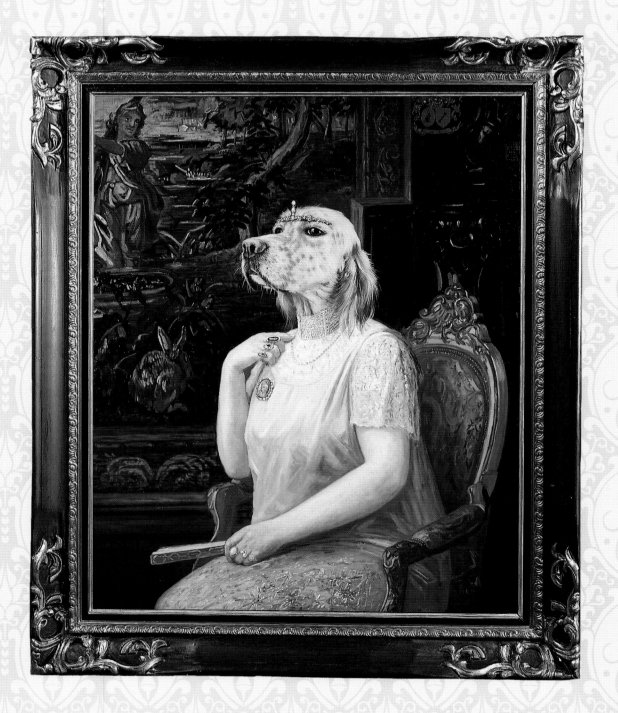

Down Boy Rag. Carlo (born Rover) and Carlene (née Trixie) had hoofed
their way up from the small-time, delivering slippers and pipes
in Birmingham, but no amount of fame and adulation could
erase the mark of those early years.

Charlotte Mumbleford

Her long reddish mane and soulful, imploring eyes gave Charlotte Mumbleford a strange beauty. Alas, violent coughing spasms had racked her body since girlhood. And yet, the reclusive Spinster of Tumbledown—too fragile to take fresh air—spoke from her sickly isolation with some of the headiest romantic verse in the language. The day she suddenly coughed up the lozenge that had gone down the wrong way long years before was an epiphany for Charlotte Mumbleford, but a setback for English verse. Quit of her affliction, she cashed in her royalties, eloped to Marienbad, and never penned another stanza.

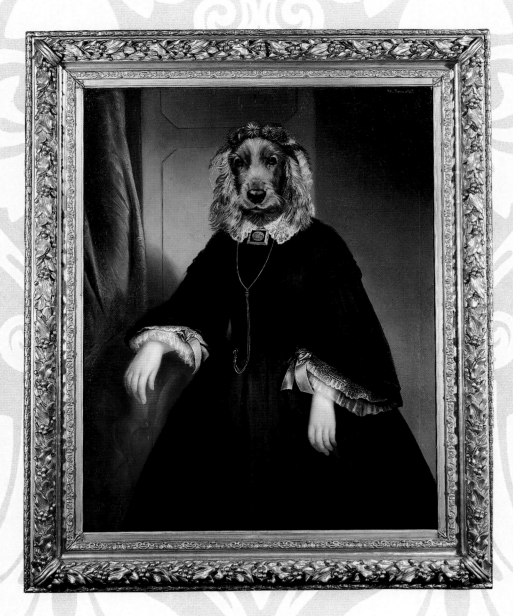

O. O. Wimbey

A kindly, lumbering giant beloved by all who knew him, Wimbey was also adored by a vast audience of late-Victorian readers for his warm and transparently autobiographical *Shaggy Dog Stories*. But where these seem contrived to the modern critic, Wimbey's slobberingly sentimental *Huxtable's Monthly* column, "Man's Best Friend," is simply unreadable today—as is his trilogy, *Meat*.

Tycoons & Grandees

Sir Isham Blovius

Dignified, austere, the Sisyphean task of flinging his Bombay & Liverpool Steam Railway across three continents creasing an already wizened visage into perpetual worry: the Sir Isham depicted here is but a hack's stereotype of the archetypal Victorian capitalist-entrepreneur. See the mischief dancing deep in those sly eyes. Amateur safecracker, ambidextrous terror of a cricket bowler, Sir Isham married the daughter of the Manchester Bobbin King—then compounded his bride's dowry by taking advantage of her chronic swoons from the vapors to woo and wed a trio of wellborn London society belles. Greased by millions of free Bombay & Liverpool shares, society conspired to keep Sir Isham's secret until the day he died. It was only exposed, in fact, at what a *Times* editorial huffed was "the most violent funeral of the Age."

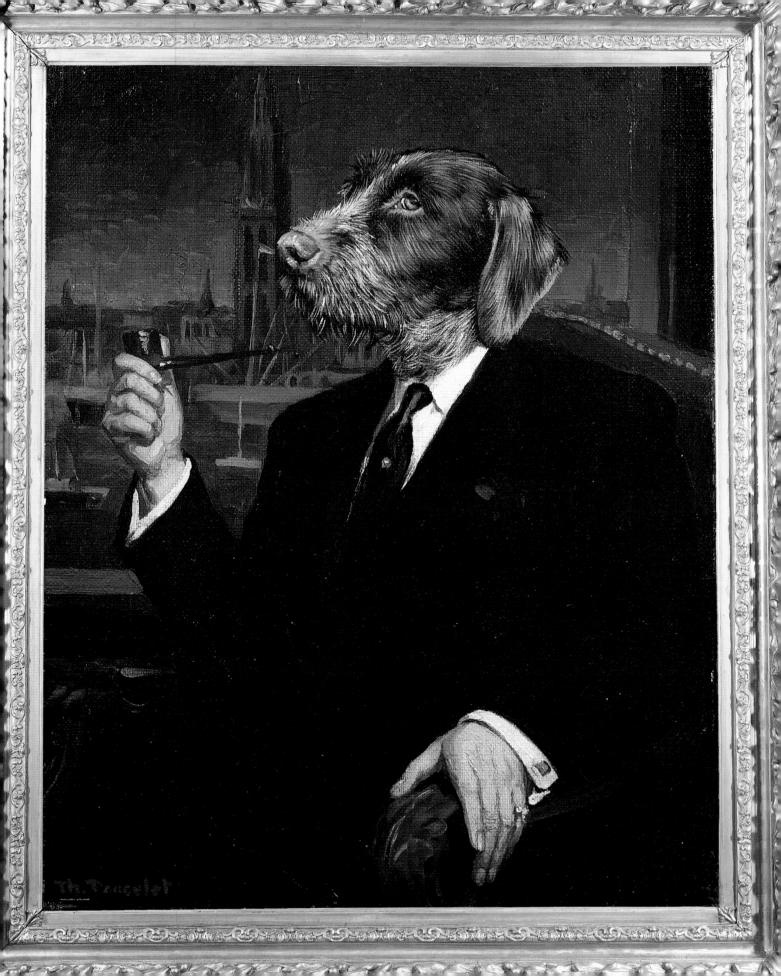

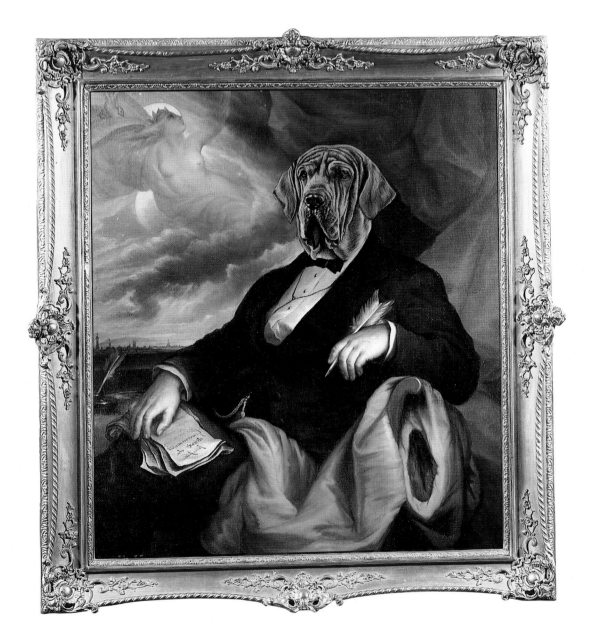

Sir Luther Deadbolt

The noted Watchdog of the Industrial Revolution is glorified by his portraitist in the grandiose style of the time. In truth, the lowborn Sir Luther never learned to read or write and made his *X* with his right hand. But he could smell an opportunity a mile away and pursue it remorselessly, before seizing it like a dog with a bone. His formidable face, so wrinkled and drooping, and his massive physique commanded respect in men and instilled terror in small children. Ironically, his own family could and did walk all over him.

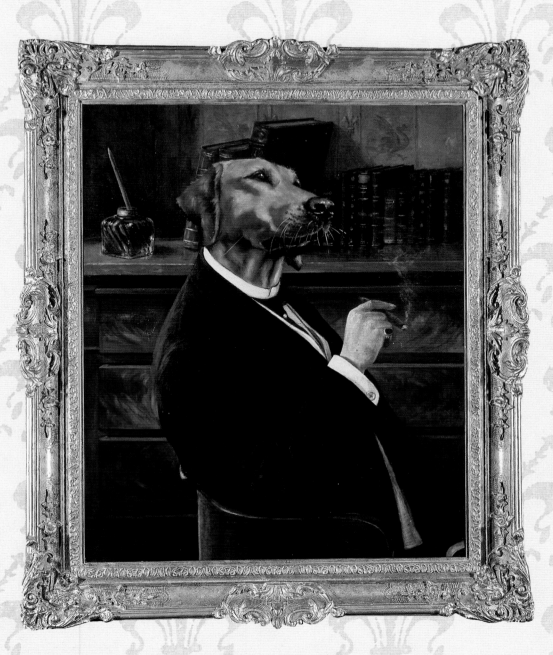

Lord Gristle

That this Labrador-born commoner of no auspicious pedigree, who had been trained on newspapers in infancy, would later become Lord Gristle, proprietor of a vast tabloid chain, seemed almost preordained. Yet deep in the psyche of this precursor of Citizen Kane were dark memories of rolled-up newspapers that rendered his calling a love-hate relationship. Buying and selling, borrowing and lending, in and out of favor with kings and politicos—his topsy-turvy Fleet Street fortunes all too vividly mirrored the conflict boiling beneath that self-possessed mask.

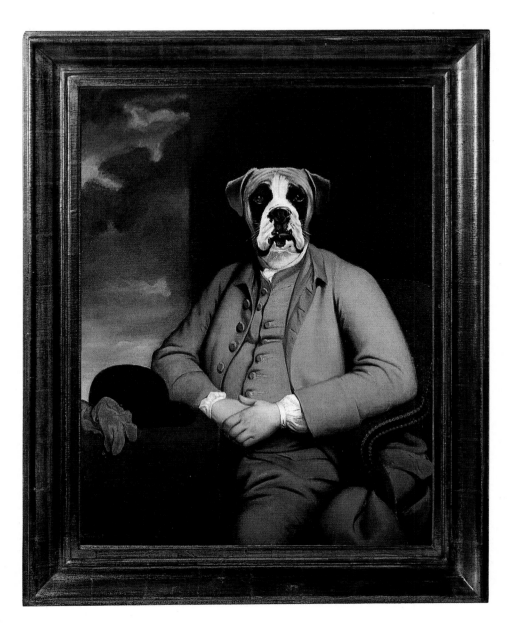

Le Comte de Montecrisco

We here confront the scion of eighteenth-century France's ranking lard dynasty. That blank yet baffled countenance, those styleless clothes might in someone else be but a clever facade for a knife-like intellect, a dashing style, a life rich in the deeper values. But Le Comte's blandness was no facade. "He has spent so much time around lard," quipped Robespierre, "that he has come to resemble it." Spared from the guillotine during the Reign of Terror, Montecrisco spent his remaining years doing what he did best—quietly sitting for portraits.

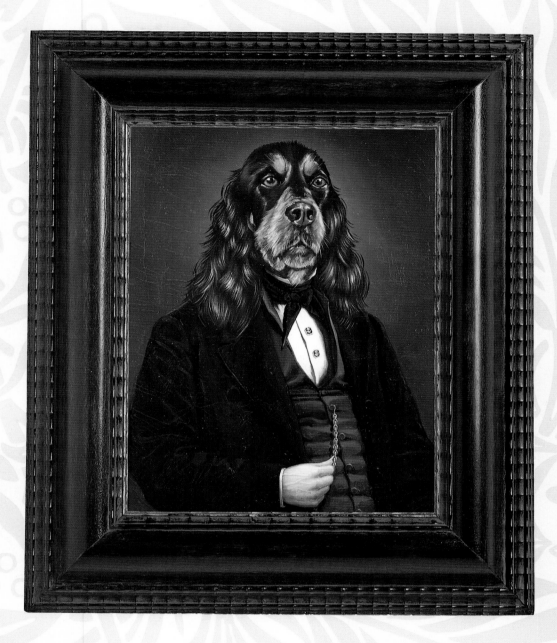

Rube Gordon

*U*nshorn, humorless, blunt Rube Gordon was an early settler of the
Colorado territory and made his fortune as a mining tycoon.
The billionaire was visiting London for the sole purpose of renting the
British Army to impose peace on the rough-and-tumble Western frontier,
when he reluctantly sat for this portrait by the Royal Academy's Sir Miles
Prower. Legend has it that Gordon's glassy stare indicates outrage at the
English painter's sneering dismissal of all things American—which might
explain the painting's not-quite-finished background.

.

*Royals &
Bluebloods*

.

King Zoxtor of Albania

This barrel-chested physical giant was an ardent exponent of what would later be called the macho ethic. He bore a lean and mean body on long, hard legs that never seemed to quite get exercise enough. Kingly obligations came second to Zoxtor's simple joy in wrestling and roughhousing and madcap impromptu sprints. One of the few times he could be coaxed indoors was to deliver his manifesto threatening war with tiny Ruritania. Ruritania ignored it—and with impunity; the gentle giant's bark was always worse than his bite.

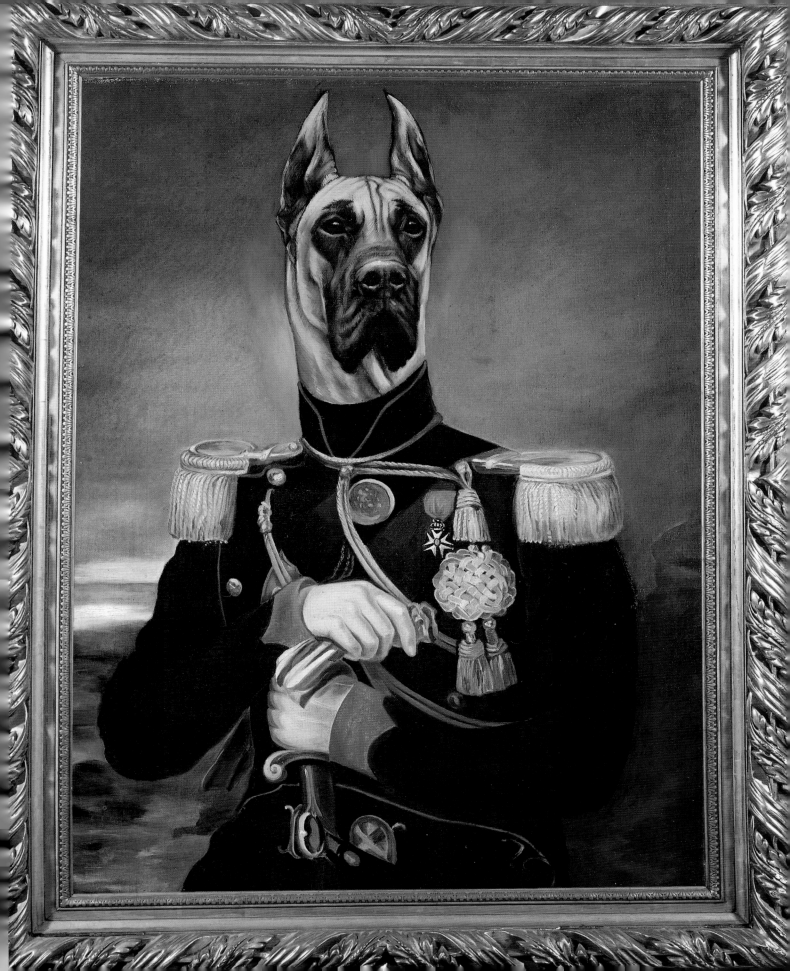

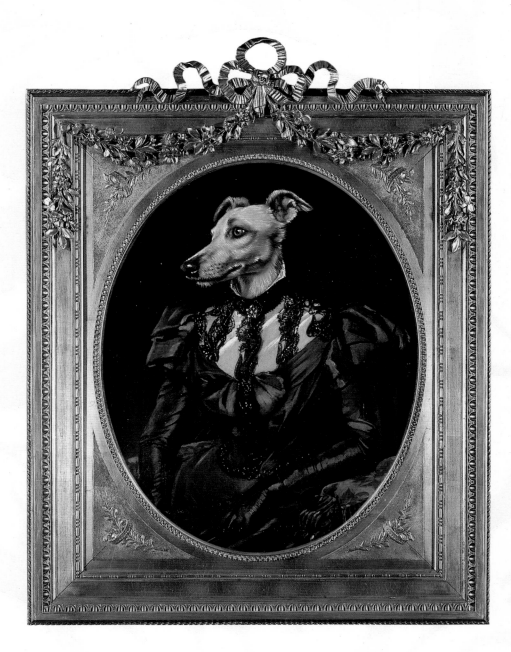

Duchess Elspeth of Troon

Elspeth Boggs's impulsive pairing with Neville, Duke of Troon, was not a success. Fancy costumes and the giddy social whirl were not for homespun Elspeth, the issue of a local shepherd and a town stray. She preferred dining in the kitchen and long walks alone. In this official portrait painted by Sir Reginald Setter in the Duchess's middle years, we see the saddest of stories limned in dour blues and blacks. Regard those eyes so full of longing, those ears cocked as if listening for the familiar bleat of a ewe. Yes, we see here one of Nature's beautiful creatures; but a countess, to the manor born, we see not.

TO

FROM

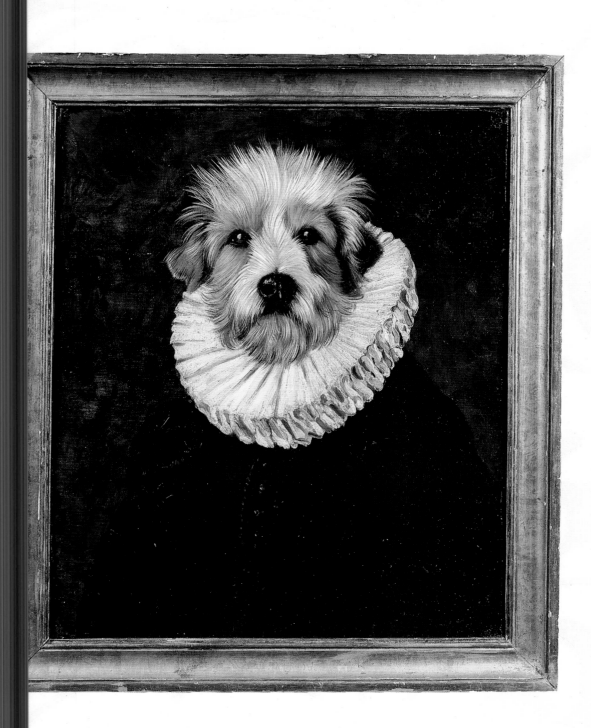

Don Vasquez y Vasquez

*L*ittle is known of this winningly unkempt Castilian nobleman except that he frequently scandalized polite Seville society with his brazen courtship of every female he fancied. He also never adapted to wearing a ruff and chewed on it furiously at every opportunity.

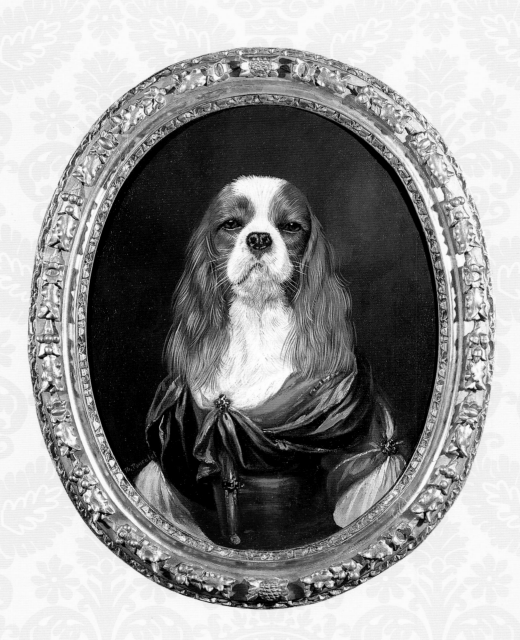

Countess Eugenie

The Austro-Hungarian Emperor Franz Josef had many nieces and nephews, but his favorite was the elfin Eugenie. Detested by most of Viennese society as a simpering little fussbudget forever poking her nose into matters that did not concern her, Eugenie ignored her detractors with royal disdain. She greedily gobbled the sweetmeats with which the kindly old Emperor always packed his pockets and grew grossly fat, and in time was supplanted as Franz Josef's favorite by what she always described as "that Pekingese bitch."

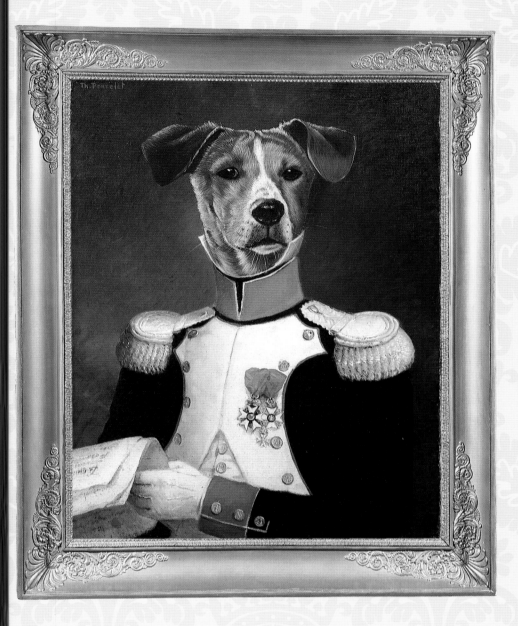

Duke Fyodor Kacharatov

His keen instincts made the ambitious Duke a natural choice
as the Czar's eyes and ears in the Byzantine maze of the
Royal Court. "He was born to chase rats," Alexander boasted.
Remarkable gifts of hearing and vision helped Kacharatov to eavesdrop
and spy with inhuman acuity; but moral qualities were absent and
his real career was soon blackmail. Exposed by the Czarina's cook for
demanding a lifetime supply of biscotti to cover up a minor indiscretion,
the duplicitous Duke ended his days in Siberia.

Don Juans & Femmes Fatales

Sir Rufus Wilbraham

Seated here in the library of Wilbraham House, the London home of the Wilbraham family since 1830, Sir Rufus was chairman of Wilbraham, the prestigious merchant bank made famous by its daring behavior at the time of the Napoleonic Wars. Sir Rufus, who took particular interest in the welfare of widows and orphans, epitomized the best of imperial British banking. He was also one of the most celebrated fox-hunters of his day. Lady Wilbraham, who was considered to have the best seat in the county, rode regularly to hounds, while Sir Rufus was often seen surrounded by a bevy of beauties in his box at the opera, introducing them to the delights of Puccini.

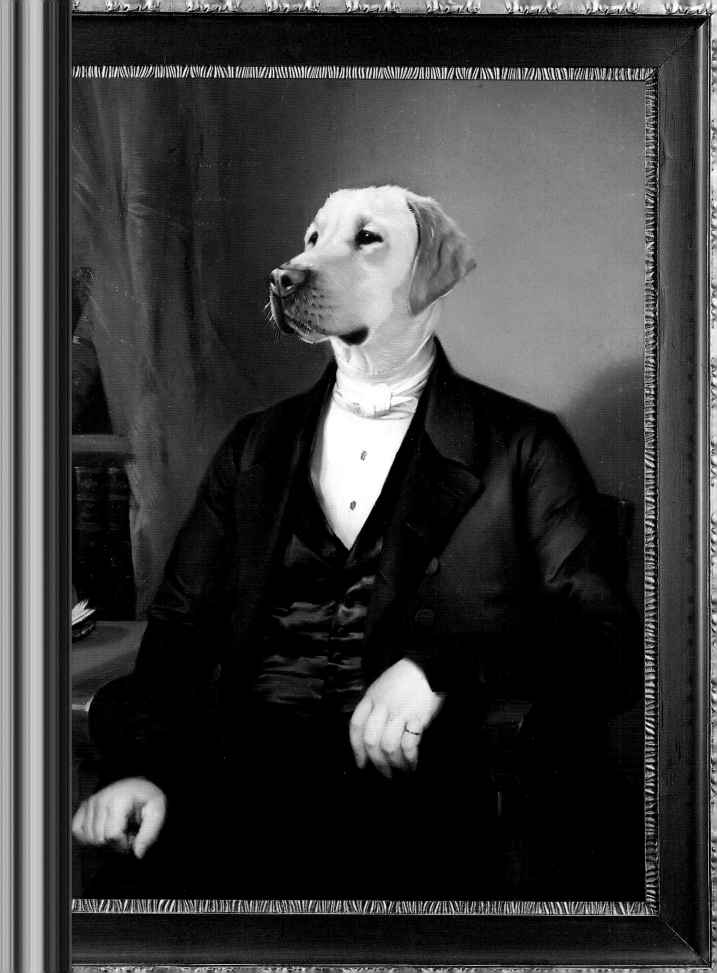

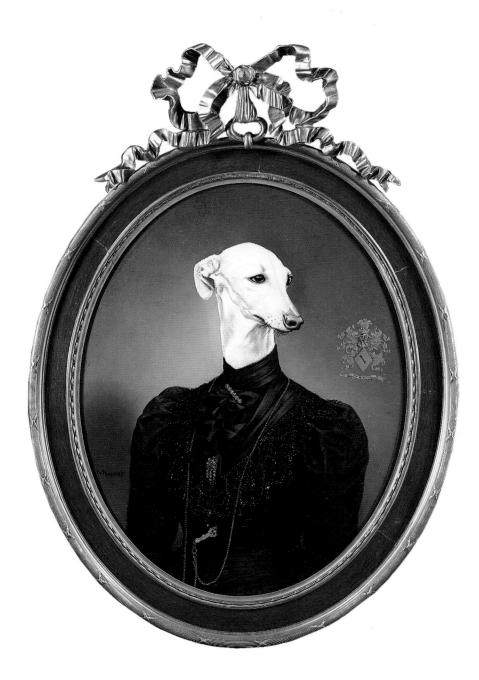

Duchess Tatiana Pavlovna

The young Tatiana left her native Russia to study in Paris but soon strayed from her intellectual pursuits. Always the life of any ball or social occasion, she was pursued by a host of young men. She married eight times in all, being dogged by misfortune and husbands who died untimely deaths. In her final marriage to the Marquis de Sader, the Duchess met her match and lost her heart.

Horace Smickley Jr.

The fortune-hunting Smickley changed his name to Vanderbilt Carnegie III, crashed London society, and soon landed himself a Duchess as rich as she was ingenuous. The happy couple boarded ship at Cardiff for what Horace billed as a honeymoon trip to survey his vast American zircon holdings; in fact, the cunning Yank convinced his bride that Brighton was actually New York. And despite Mrs. Carnegie's chronic homesickness for England, they lived there in happy splendor the rest of their lives.

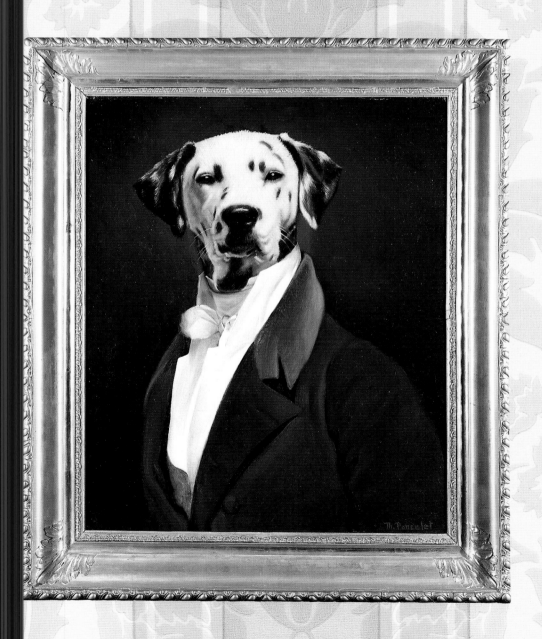

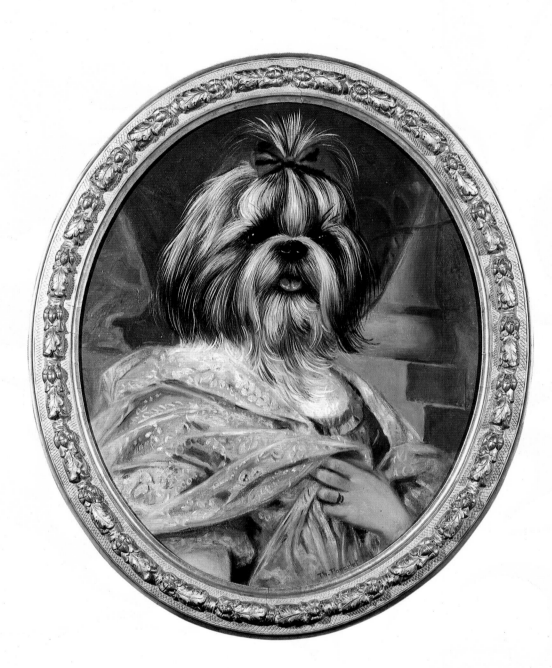

Doña Marissa Navarro

Doña Marissa sat for her portrait at Casa Perro, her family home in Seville, shortly before her marriage to the Duque of Catalan. Though fifty years her senior, the Duque fell helplessly in love with her large blue eyes and enchantingly girlish disposition. Sadly, he did not live long after their marriage, but the Duque is said to have died a happy man.

Maurice Maurice

*H*is conquests on the stage were no match for the vain and aggressive Maurice Maurice's conquests in the boudoir— that is, if one can visualize this dappled forest clearing, that greensward, even the sidewalks of the Trocadero as boudoirs. An incurable exhibitionist as well as an unquenchable satyr, Maurice more than once had to be dissuaded by buckets of cold water or a fire hose for decency's sake.

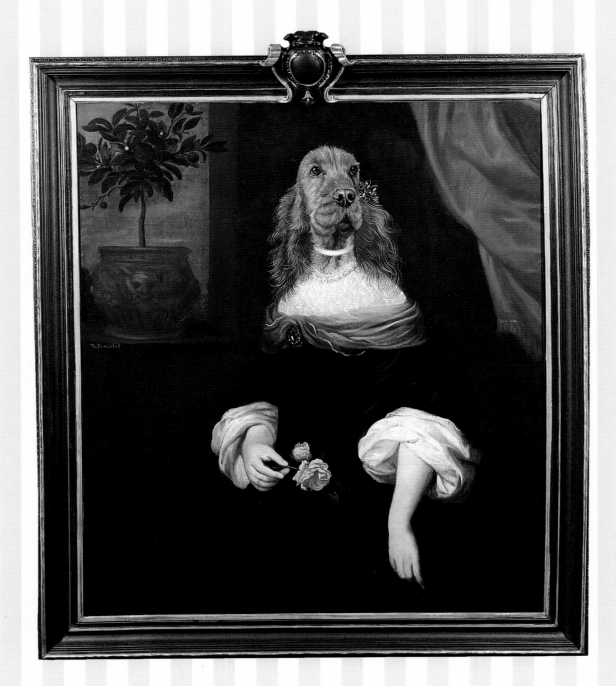

Agnes Courvoisier

Her stage name reflected the brandy-colored locks that were her trademark and which made this dreamy-eyed ingénue the center of attention wherever she went. That she stole hearts was entirely predictable, for there was about Agnes Courvoisier an intoxicating mélange of fire and gentility. That she also stole hose, slippers, and chemises was perhaps equally predictable; it was all too typical of her kind.

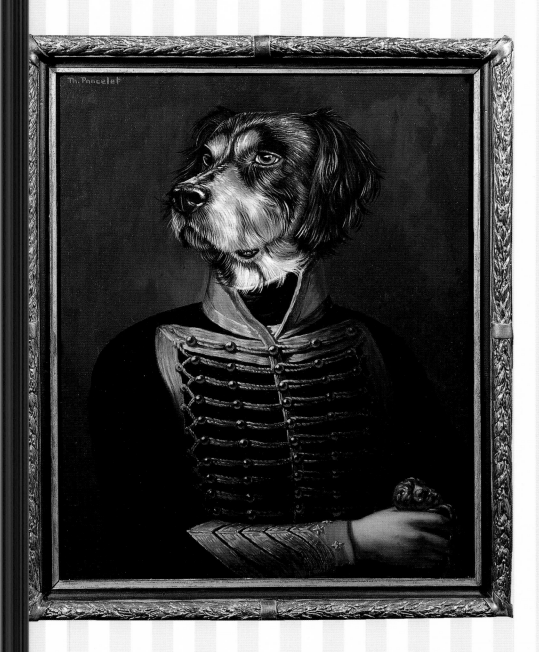

Marquis Don Filippo del Cruzero

"You are not a nice man," wrote a grieving mother to the swarthy Brazilian who had just traded her daughter, the Infanta, to the Berbers for a set of steak knives. Six months later, Donna de Angeles had become his bride. There was charm in the dashing nobleman, and cruelty, and caffeine—far too much caffeine, for he had grown up unsupervised on his family's billion-acre coffee planta-ion. When on his honeymoon with Donna, he met the pudgy and bowlegged Princess of Sanka, he was smitten. "You are *certainly* not a nice man," wrote his jilted bride.

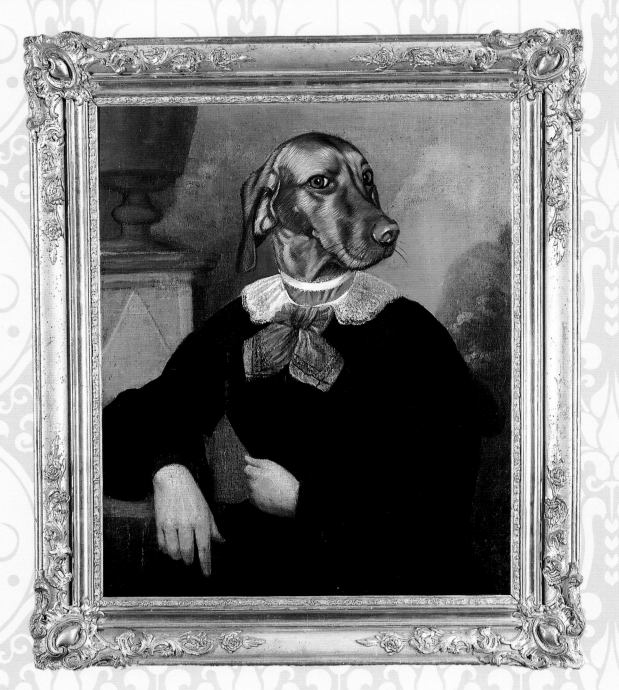

Alma Mater

*P*reserved in oils before you sits Alma Mater, the dutiful wife of
a *fin de siècle* composer. For seven years this stunning Viennese
beauty had sublimated her own ambitions—musical and otherwise—to
minister to his needs. But three days after the completion of this
portrait, Alma left for Tobelbad to take the waters. There she cast
off the stiff lace collar and repressive conventions that stifled her true spirit
and began a torrid affair with the young architect Walter Groper.
The resourceful Alma had cured herself.

Alexei Pachinko

Too many boxing matches had stoved in his face. He rasped and wheezed with undiagnosed asthma. He suffered all his life from gas. And yet Alexei Pachinko cut a swath through the salons and boudoirs of St. Petersburg society by pretending to be the Pretender to the throne of France. He slept in the beds of many a countess in his time, but a natural indolence and a love of snacks left him fat and wrinkled by middle age. He dozed his life away on satin pillows, a lapdog of the rich.

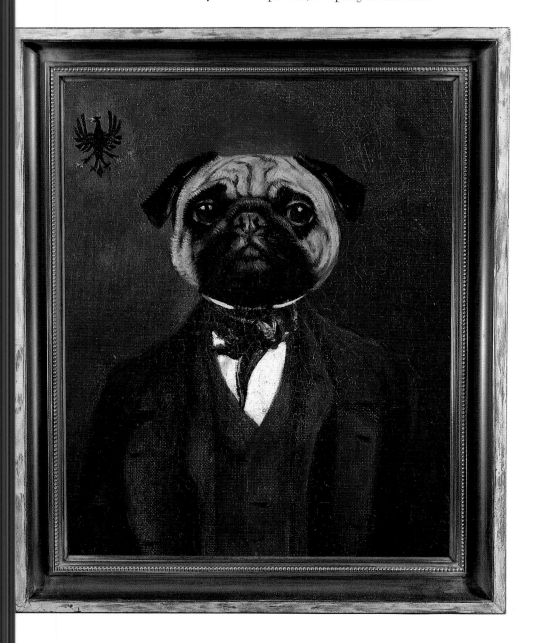

Swashbucklers & Athletes

Bodo Schnopf

Muttonchop whiskers silver with frost, ears folded over into natural muffs—here came Swiss contra-climber Bodo Schnopf, scuttling down with the speed and sure-footedness of a mountain goat. Down the Matterhorn, down the Zugspitze, down everything that millennia of Alpine geology had ever thrown up. Climbing, he snorted, was against the laws of God, Nature, and gravity. Awarded the Medal of Valor by the Bern Institute of the Foolhardy after tumbling thirteen kilometers down a glacier, Schnopf arrived for the ceremony— but at award time was nowhere to be seen. Confusion reigned until the janitor reported the obvious: Bodo had entered the building and instantly headed straight down to the basement.

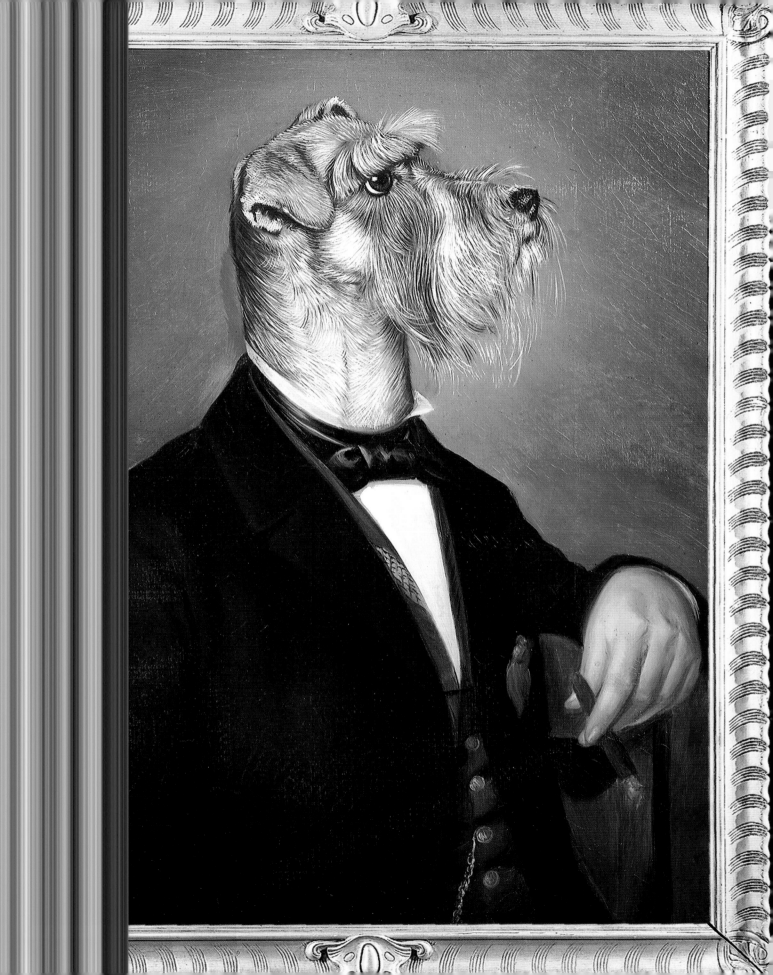

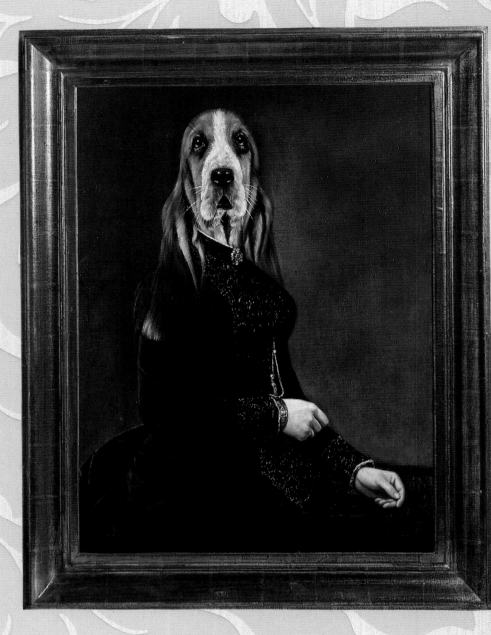

Dame Ethel Brack-Muggins

'S he whelps more often than I bathe," snorted Lord Noseworthy.
True, Dame Ethel was at an early age the mother of sixteen, by
divers anonymous fathers. Yet her inborn dignity and warmth—and her
uncanny natural instincts—ensured her acceptance into the best homes in
England, particularly on fox-hunt weekends. Her compulsive impromptu
assignations continued virtually her whole life long. Her get exponentially
multiplied. That Dame Ethel nonetheless kept her figure, her robustness, and
her sharp senses well into advanced age is vouchsafed by this imposing portrait.

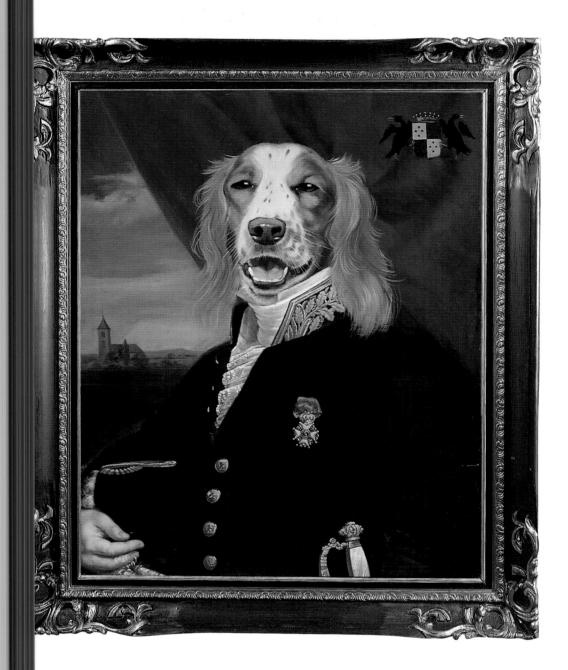

Commodore Sir Giles Mallard-Stalker

Breeding is no assurance of merit. The long-faced, big-eared, loose-limbed character squinting out from this portrait makes an instructive example. Sir Giles had been around water his entire life, yet he was an abject if not scandalous failure as Commodore of the Scilly Isles Yacht Club. It happened over and over: no sooner had the sloop under his command slipped anchor and made for open sea than Mallard-Stalker leapt overboard and started swimming for shore.

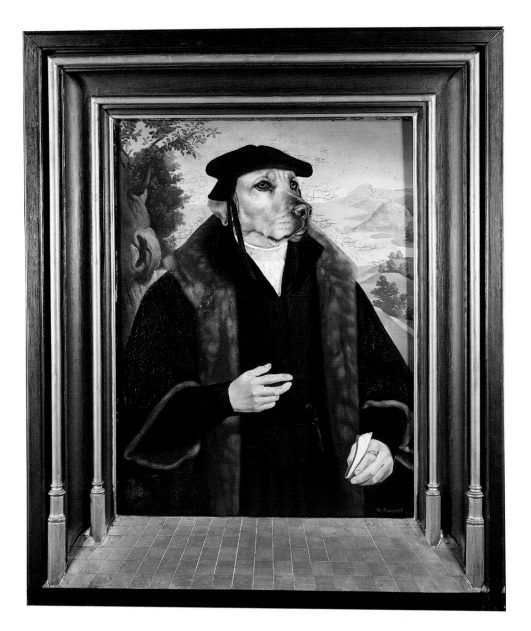

Sir Bulford Chipwich

The trompe l'oeil frame and hyperbolic background form a fitting setting for the man who walked alone across Baffinland and back just to retrieve a lost muff; who was stranded for three winters at Antarctica's desolate Desolation Inlet before sailing to freedom in the four-masted schooner he had fashioned of lichen and ice; who, marooned again when his ship melted, subsisted for nine months on a diet of pocket lint. It was ironic, nay tragic, that this adventurer nonpareil should expire by choking on an ice cube during cocktails, prior to his induction into the Explorers Club Pantheon of Fame.

Miss Eulalie Featherbridge

Petite to the point of dwarfism, wiry, walleyed, and virtually chinless, Miss Featherbridge would win no beauty accolades. But the only prize she coveted was to be the fastest penny-farthing rider in the realm; and in a fifty-mile grudge run versus champion Jack Mudd, "The Hatfield Hercules," she so became. A year hence she was to become Mrs. Jack Mudd and directed her competitive zeal to raising the largest litter in the Empire.

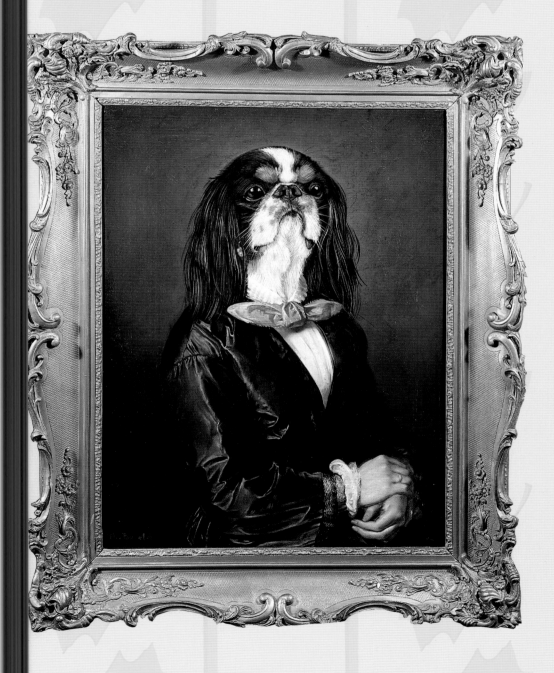

Explorers & Visionaries

August-Karlfried Pfummel

Digging was August-Karlfried Pfummel's obsession when but a lad; that it was he who unearthed the only Indian arrowhead ever found in central Europe, and the bones of a human later proven to be his own great-great-great-great-great-great grandfather, epitomized the luck that shone over his long archaeological career like a halo. The final example was the gaudiest: insisting on digging his own grave, the aged Pfummel had excavated to only five feet before his shovel clanged on something solid. It was an iron chest containing Charlemagne's long-lost address book.

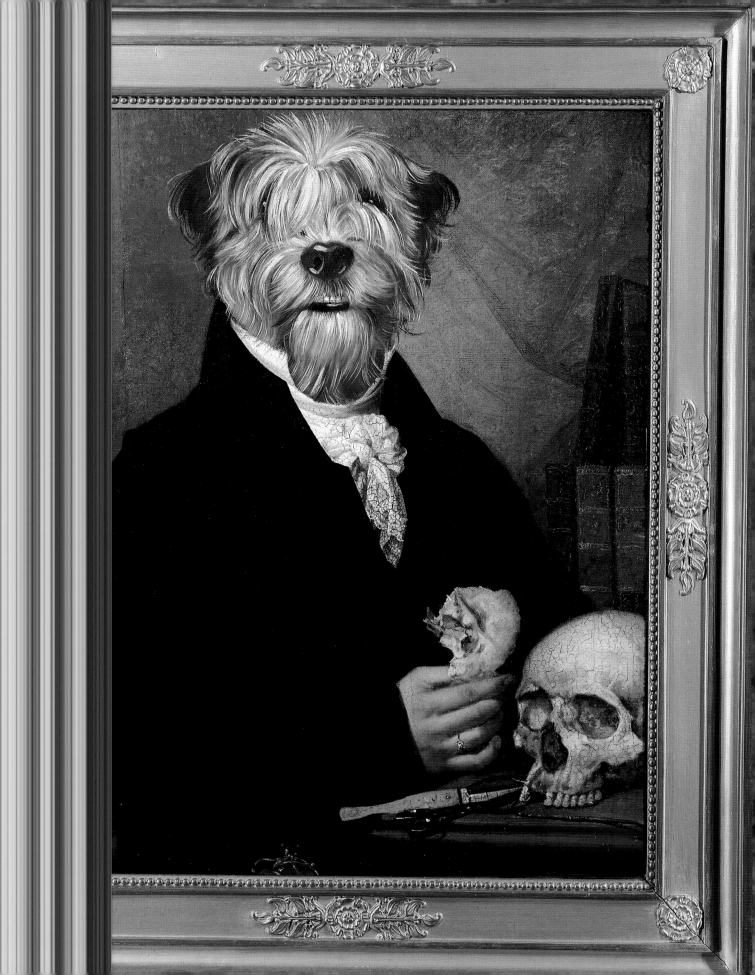

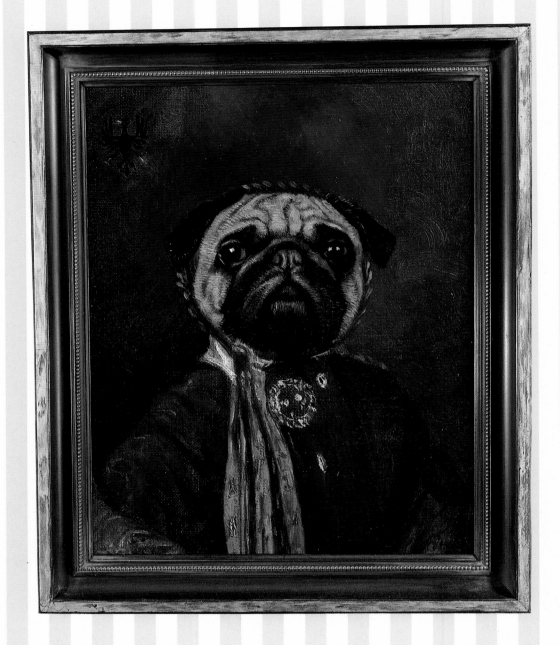

Madame Dr. Hortense de Mops

"Pugnacious" only feebly describes this redoubtable French scientist. Spurned by the august Academy of Ideas for theorizing that clouds are not solids, and offered a charwoman's pail instead of membership, Dr. Mops pumped a laboratory-made stratocumulus into the Academy's chambers during its annual awards ceremony—leaving her doubters moist and chastened. Wed only to her work, she became more beloved as she aged, proudly bearing the honorific of Dowager Emeritus of French Science.

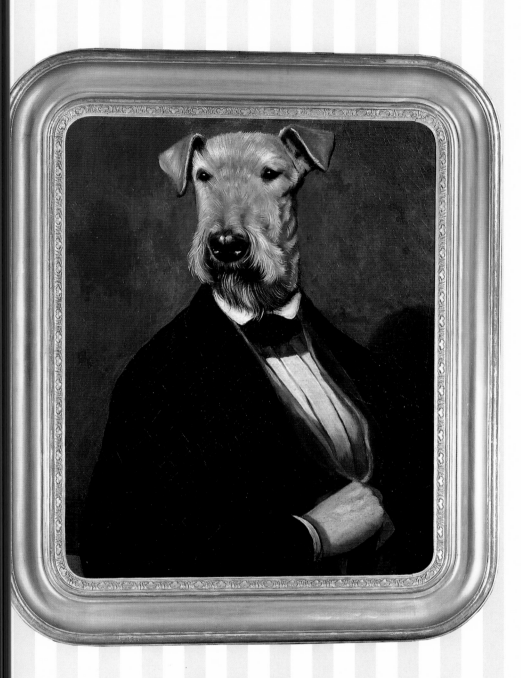

The Fifth Earl of Hearsay

Gruff and eccentric, "Old Whiskers" panted after fame without ever quite
grasping it. His expedition to find the East Pole, his overland rope-pulley
mail service to Egypt, his discovery that Shakespeare's works were the work of another
man named Shakespeare—all futile. His lone real achievement was the founding of
the British Narcoleptic Society, but since all written records of the Society's
deliberations peter out after only a line or two, it was not a lasting one.

Sir Duncan Wilberforce

Note that behind the celebrated late-eighteenth-century Scots inventor in his Edinburgh study, two bound volumes are absent from their place on the bookshelf. The slyboots portraitist is making droll comment on Sir Duncan's notorious absent-mindedness. But as that penetrating gaze attests, his eye was ever fixed on a plane behind the beyond, on things that other mortals could not see. And in the foreground, some of the results: the double-barreled twin quill pen and Sir Duncan's most lasting gift to mankind—single servings of instant haggis in a can.

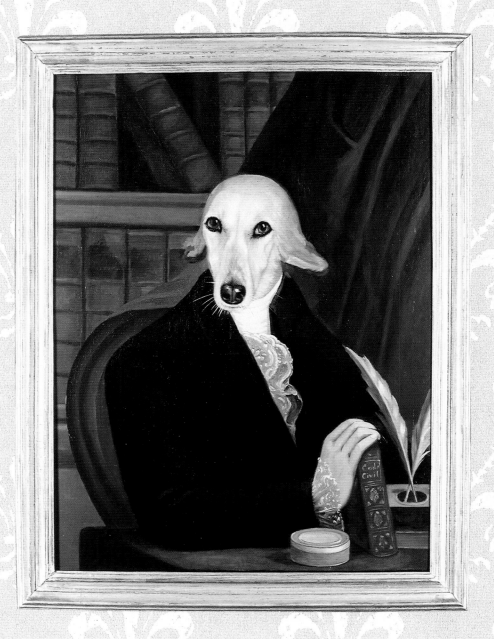

Amanda Des Moines

The most talked-about dressmaker of the Second Empire, Madame Des Moines is caught here in mid-creation as she raced between fittings in her little attic shop above the rue de la Paix. Her daring couture innovations startled the world: aggressive patterning of soft leather gloves and shoes, bonnets of sheared lace, gowns with irregular hemlines, and raglan sleeves.

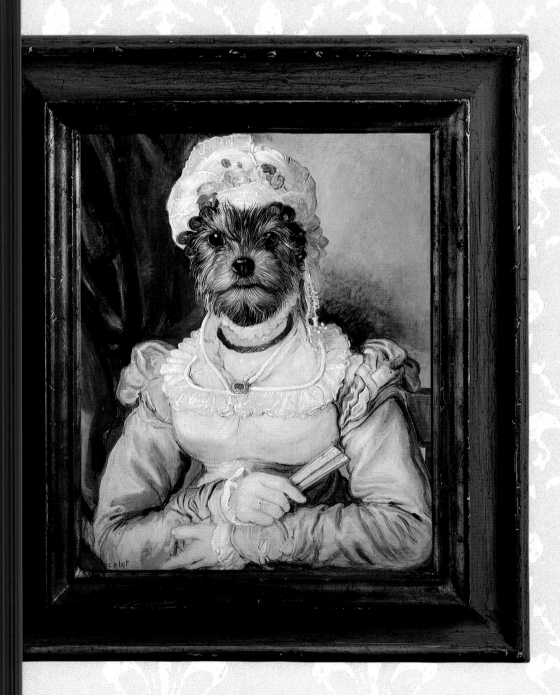

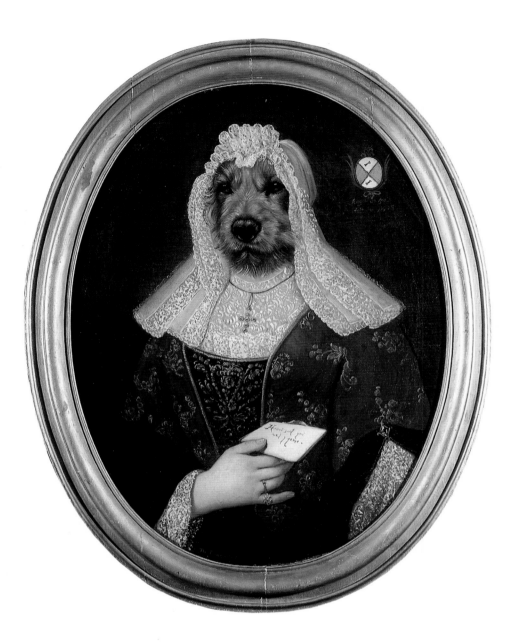

Frau Irmtraud Katzundhunde

Errant social climbing was her vice; all her life, for example, she claimed to be born Pomeranian, although the Dresden-born Frau Katzundhunde's true lineage was as plain as the prominent nose on her hirsute face. She swiftly became the leader of her Dresden social pack and a favored protégée of the rich and powerful. So important was such acceptance that she blithely acquiesced to ride about town not inside the carriage with her patrons but up with the coachman in the open air.

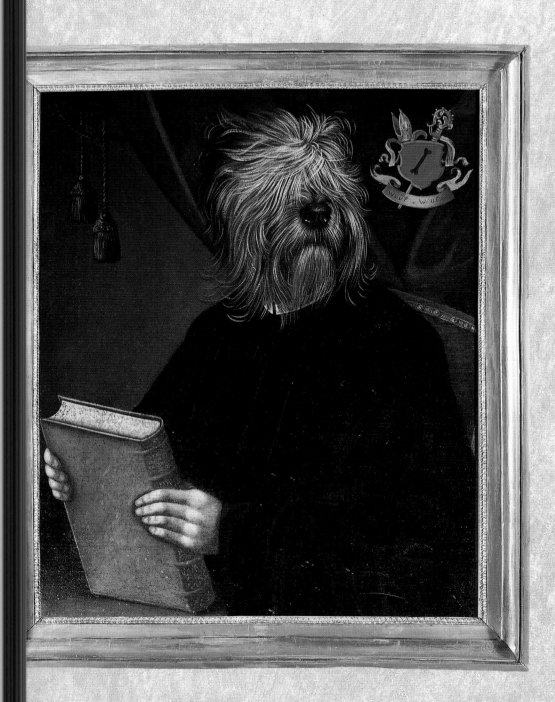

Nils Andersen

Too lost in his own inner world to tend to such mundane matters as grooming, this learned philosopher would spend years brooding on the maddening space-time conundrum known to his peers as Andersen's Paradox, and to laymen by the familiar phrase "You can't get there from here."

Cads, Rotters, & Roques

Madame Blahatska

The ethereal Russian mystic who had all London society agog with her occult powers was, in fact, Daisy Weembs of Cheapside—a wolf in widow's lace. In retrospect, the "predictions" that so bulged her coffers and so boggled her victims seem tame stuff indeed: gazing into her crystal ball, she whispered to the Duke of Posh that he would feel drowsy come midnight; she predicted that Lady Dora Morpeth would soon see a reflection of her own face in the mirror. Her soft brown eyes and otherworldly presence might have blinded the gullible indefinitely, had not fads changed. When the "science" of Digitism swept London and fortunes could be foretold by the length of one's fingers, her clientele evaporated overnight.

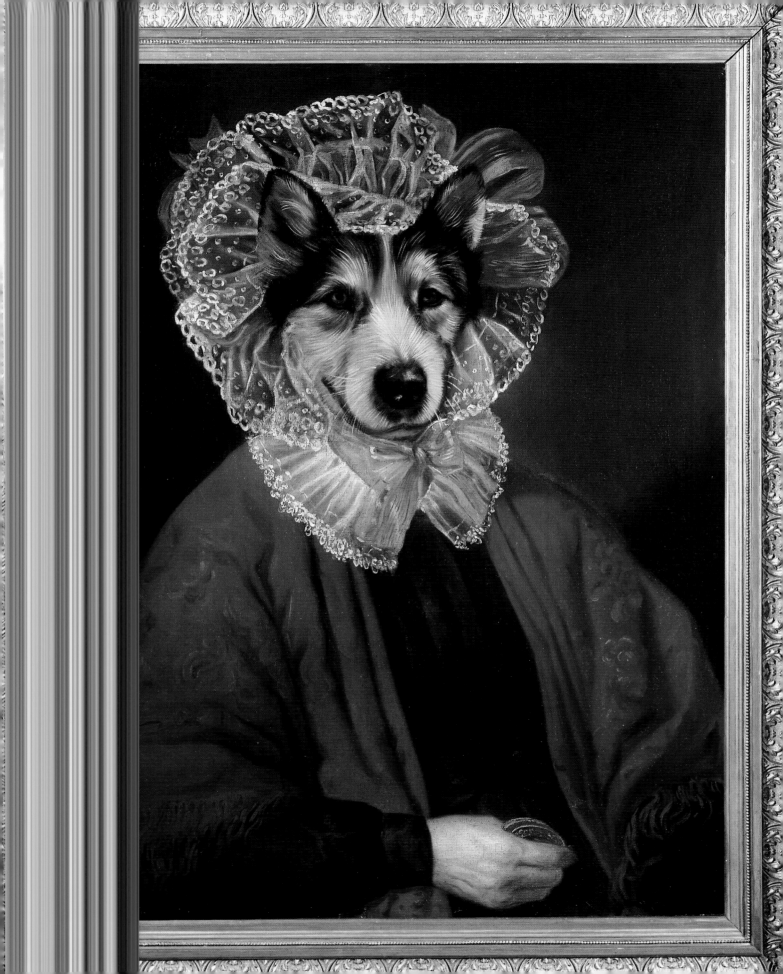

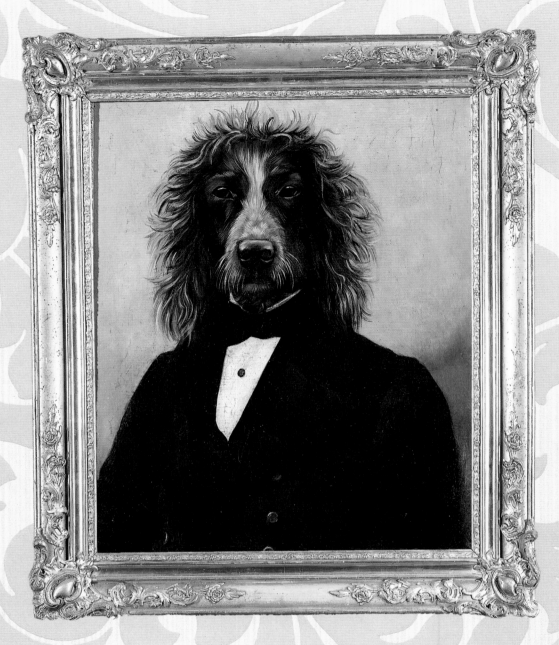

Yuri Malishnikov

Perhaps chess mastery came too easily to Malishnikov. Perhaps
cheating injected thrilling risk into what had become routine.
He would fill his pipe with chalk dust and puff till his adversary was blinded.
He packed the audience behind him with professional stripteasers.
Malishnikov was ultimately barred from championship play and ended up as
a duck-hunting guide near Sebastopol, where his lightning moves and
dazzling feints devastated the ponds as they once had the chessboards.

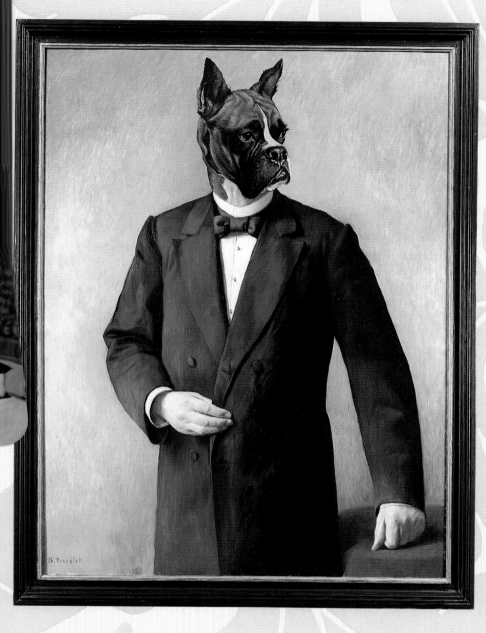

Edouard "Coupe" de Ville

One notable transport to the New World was Edouard "Coupe" de Ville, a distant French relation to the Marquis of Queensberry. He was known from Newport to Southampton as a bon vivant, a dazzling amateur pugilist, and an eligible but elusive bachelor. In the criminal underground, however, de Ville was known as "Paris Eddy," jewel thief and society burglar. Oddly, de Ville despised personal adornment and had a habit of referring to necklaces as "choke chains." He wore no jewelry, not even a watch.

Wally Bean

There is more than deviltry in those beady little eyes. Call it larceny. King of the ocean-going cardsharps who proliferated in the era of the trans-Atlantic luxury liners, Bean was not only quick with his sleight-of-hand at the poker table but fast on his feet when found out. Surer of foot than any pursuer, the runty flash ran his would-be captors a merry chase from deck to deck before vanishing into any of a thousand hiding places.

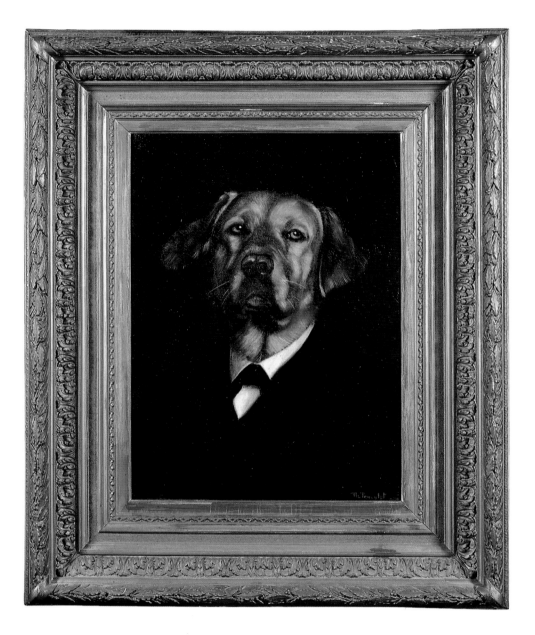

Emile de Snide

Animal cunning and a wet nose were his trademarks; even the painter of this elaborate portrait seems to have been driven to render a mug shot of France's most notorious and prolific counterfeiter. Snide forged notes excusing himself from school as a lad, graduated to laundry tickets, and then land deeds, before faking the four-billion-franc banknote that did him in. Arrested and imprisoned, he forged his release papers, an official apology, a passport, and a first-class steamship ticket to French Guiana, and was never seen again.

Persons of Great Affairs

Percival Horace Denbeigh

Britain's foremost military correspondent combined inexhaustible energy—he followed Kitchener from Alexandria to Khartoum on foot—with a knack for always being at the very heels of the mighty. At the London Naval Conference, he sat under the table. He observed the Battle of Jutland lying on the deck of Admiral Beatty's flagship. He had to be kicked away from the best vantage point by General Rawlinson in three of the Boer War's major engagements. Tenacious and indefatigable, Denbeigh possessed as did none of his contemporaries the prime requisite for a war correspondent—an infallible nose for news.

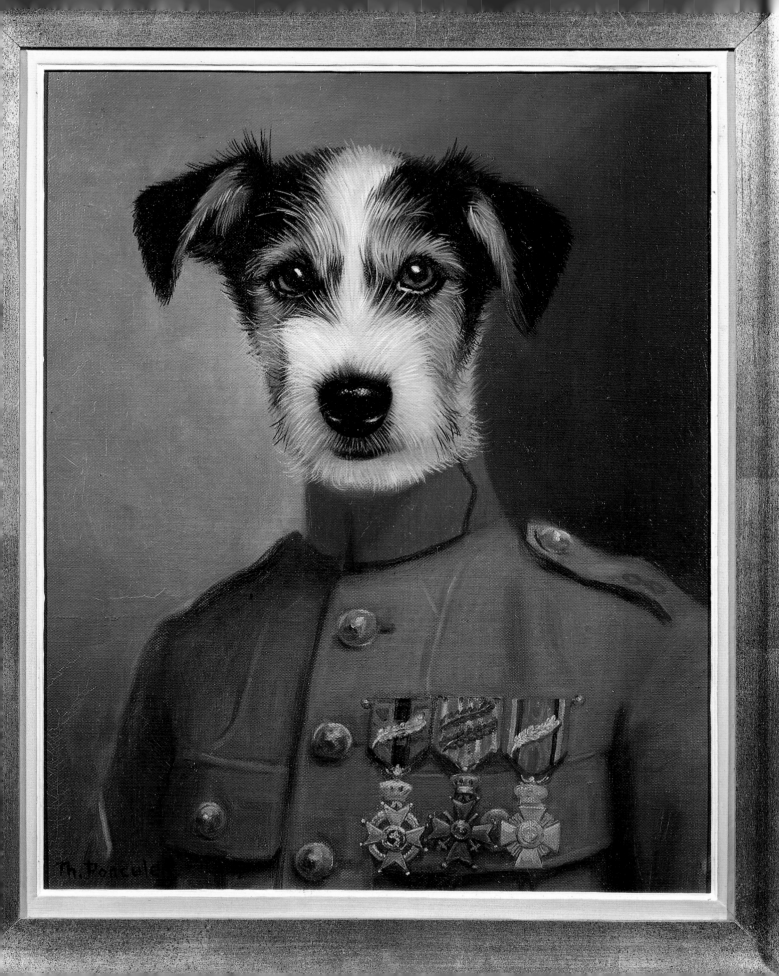

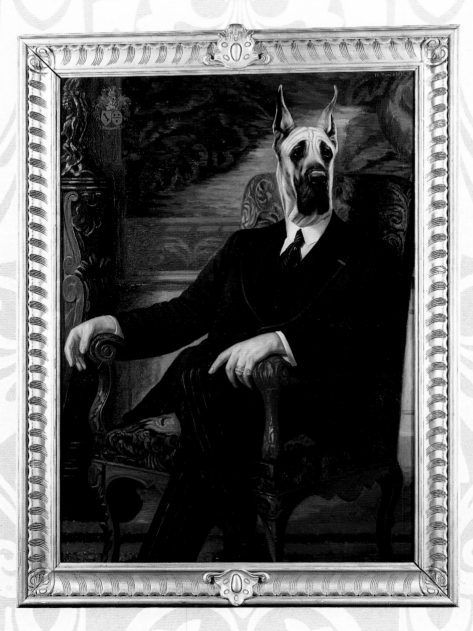

Hartmut von Bierstadt

*B*ehind that doleful mien lurked one of the Second Reich's most playfully cunning minds. The Kaiser's dashing haberdasher, Bierstadt used to rifle Wilhelm's pockets during fittings and substitute memoranda forged in the Kaiser's own hand: "Order extra tuxedo pants for Bierstadt" … "Bierstadt's nephew as Postmaster — Great Idea!" Only when he discovered that his Cabinet was composed exclusively of Bierstadts, did Wilhelm grasp the awful truth.

Karl-Heinrich Mutz

The only mute ever to gain the post of Chancellor of the German Reich was a top dog of the Wilhelmine era. "He makes everything so black and white," marveled Bismarck. Dalmatian by birth, Mutz blended a regal carriage with sinewy athleticism. His pyromania—he once stood up the British Ambassador to go racing off to a four-alarm blaze—might have been tolerated, but Mutz flouted it. His Berlin quarters were not in fashionable Wilhelmstadt, for he preferred the company of firemen to that of diplomats. All in all, a distinguished but spotted career.

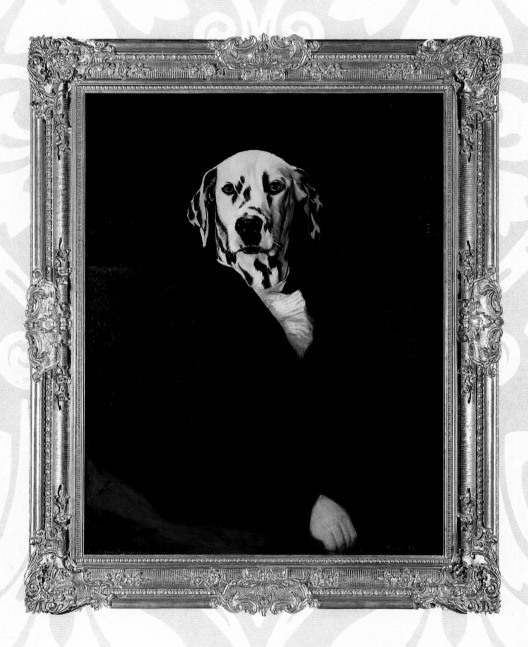

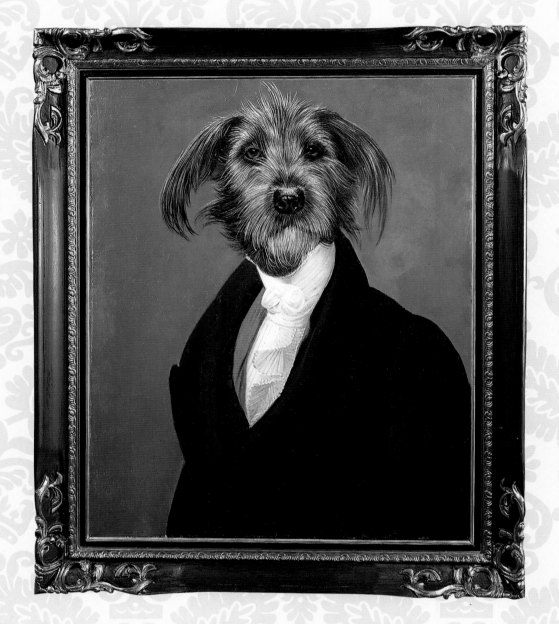

Georgi Ablomolotovski

A familiar sight as he dogtrotted along the streets of Moscow in
search of mischief, the renowned poet-editor was the subject
of his contemporary Pugov's epic poem, *Wrek Roskaya*. He is depicted
with heavy-handed symbolism as "The Destructive One," ravaging
the motherland in an orgy of gleeful nihilism. Withal, he was a garrulous
figure who ran with the pack—and frequently stopped for refreshments.
"Blavska nogi dogva boozkalivski," sighed the painter of this portrait:
"I think the old dog was pie-eyed."

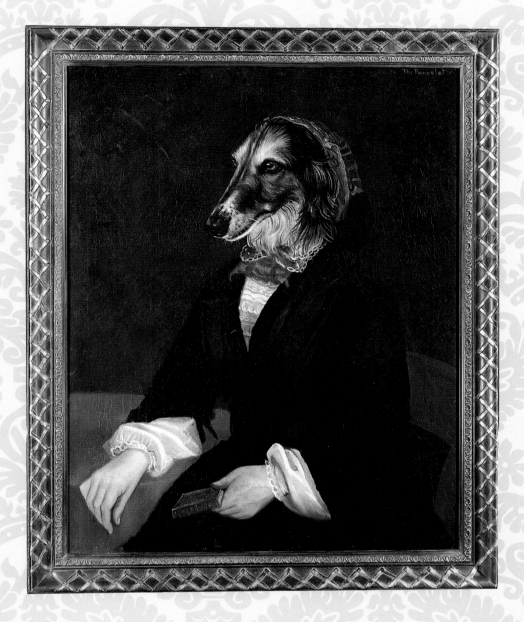

Miss Neva Sneldrake

Headmistress of Aberdeen's strictest and most austerely Calvinist girls' boarding school, Miss Sneldrake set a poor example for her young wards: running in the halls, diving into her evening meal without regard for the dinner gong, taking a lighthearted view of indoor work and a serious view of outdoor pleasure. "Every day is Field Day for this Lassie," tsk-tsked one Master. Yet it was her very unconventionality, her *joie de vivre*, that so endeared Miss Neva to the students of Robert Hall.

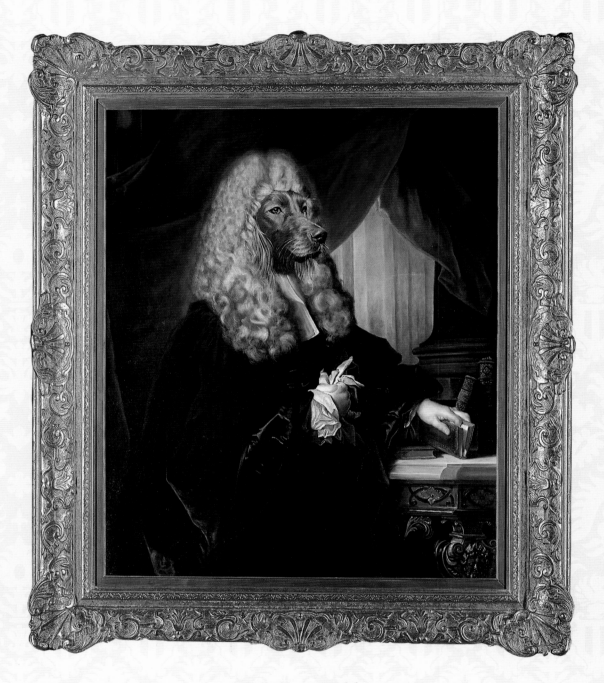

Sir Obsidian Smuckles

The High Magistrate of the Privy Court was known as a hanging judge—he hung around the house, and on the lawn, and in the fields of the comfortable country estate where he was born. The pursuit of game was more to his liking than the pursuit of justice. The only death sentence he ever passed was on a hapless ptarmigan.

Jacques Russell

'He is a terrier," marveled Emile Zola at the bandy-legged little agitator from Marseilles, "although a son of a bitch."
Born poor, an early radical once arrested for dropping water bombs on Napoleon II from atop the Palais des Madeleines, Russell lasted but four days as Premier: "Monsieur," fumed the Speaker of the Assembly, "you must go, you and your constant, endless, demonic yapping."

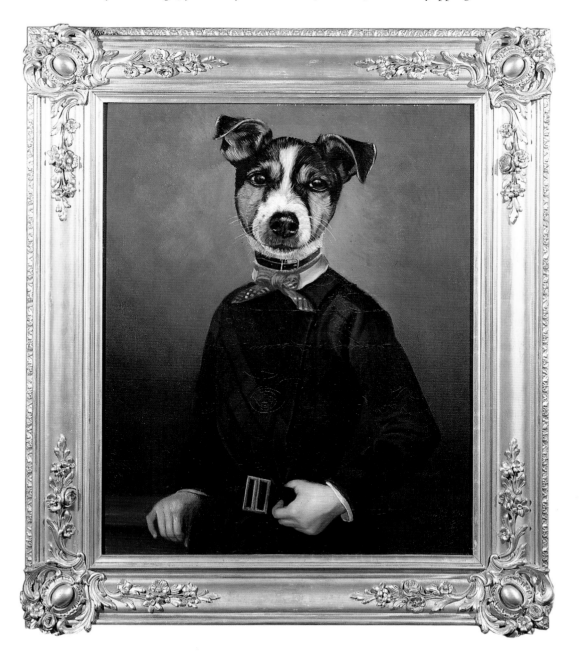

Nadia Borovinka

The Czar's favorite cook could perform wonders with a handful of beets, some sour cream, and a dash of chives. It was the image of her welcome-home banquet that sustained the survivors of the Battle of Borodino on the long trek back to Moscow. Unfortunately, no one was fonder of her cuisine than the pudgy genius of the royal kitchen herself. As fast as Nadia could cook it, she ate it. When empty plates greeted guests at the official dinner for the visiting Emperor of Austria-Hungary, it was time for Nadia Borovinka to go.

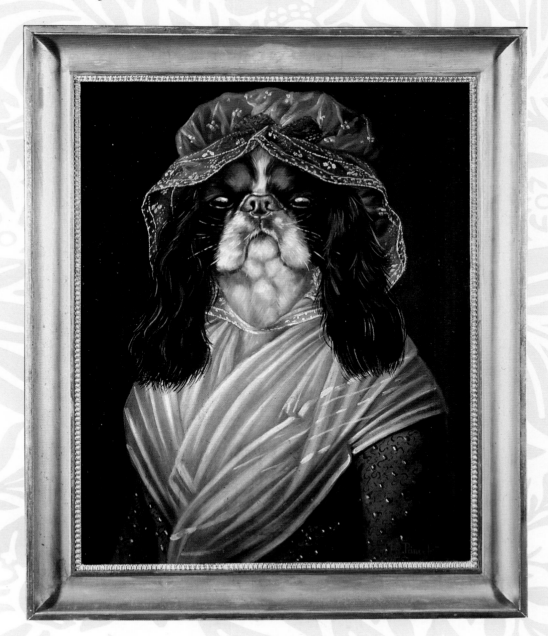

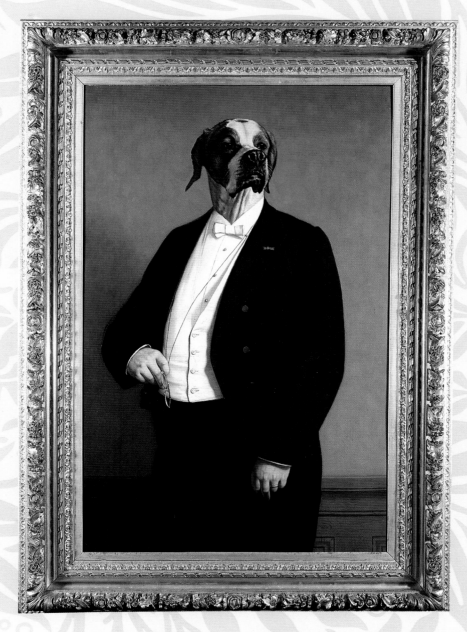

Sir Harry Pobjoy

Commissions to paint the great and the near-great poured into Harry (later Sir Harry) Pobjoy's London studio. An unctuous flatterer in oils, he rendered the 300-pound Lady Fescue as a fawnlike wood nymph and the midget industrialist Lord Swindle as an ectomorph in a Roman toga. The handsome rewards of Pobjoy's shameless idealizing of the wealthy allowed him to lay down his palette and hire the premier realist of the day to paint him.

Baron Lutz von Wag

Beleaguered little Moravia survived the constant threats of central Europe's bullying major powers only through the efforts of sprightly little Foreign Minister Baron Lutz von Wag. Constantly dashing hither and yon, the diminutive dervish ran circles round his diplomatic adversaries—never sitting down at the conference table, thus never a signatory to a document that might trap Moravia. It was only when the Baron began to age that destiny caught up with Moravia; central Europe's delicate balance was upset, and the lamps whose posts von Wag had so often frequented went out all over Europe.

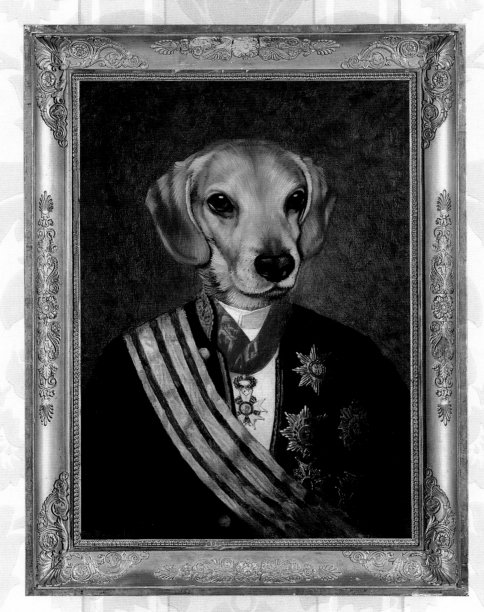

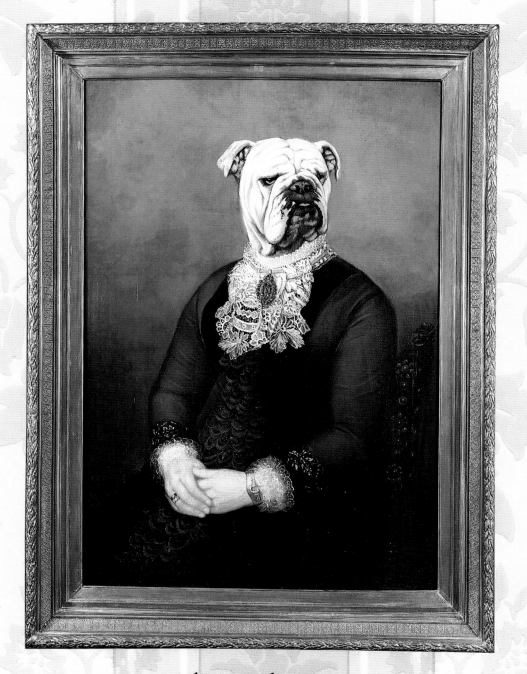

Madame Sophie Argent

*I*nvitations to Madame's Sunday salons in the stuffy apartment on
rue Atilla were declined at one's peril: painting commissions could
evaporate, manuscripts could return unread, recitals could be cancelled.
"She drools, she has bad breath and dewlaps, she snarls at every new arrival,"
an exasperated Flaubert confided to his journal, "yet they dote upon her!"

Denizens of the Demimonde

V. V. Pnin

'We are leashed to our masters and made to go only where they go," thundered Viktor Vladimir Pnin in a typical self-published broadside. "To the corner, to the gutter, and if lucky, to the park. Pah!" So often exiled to Siberia that his personal food bowl and straw mattress were kept in permanent reserve, Pnin was more than willing to pay the price for circulating his incendiary diatribes against the hated laws that impeded his freedom and that of thousands like him in mid-nineteenth-century St. Petersburg. But all his fire and eloquence were unavailing. The laws never changed. "Poor Pnin," sighed his best friend Pushkin, "always baying at the moon."

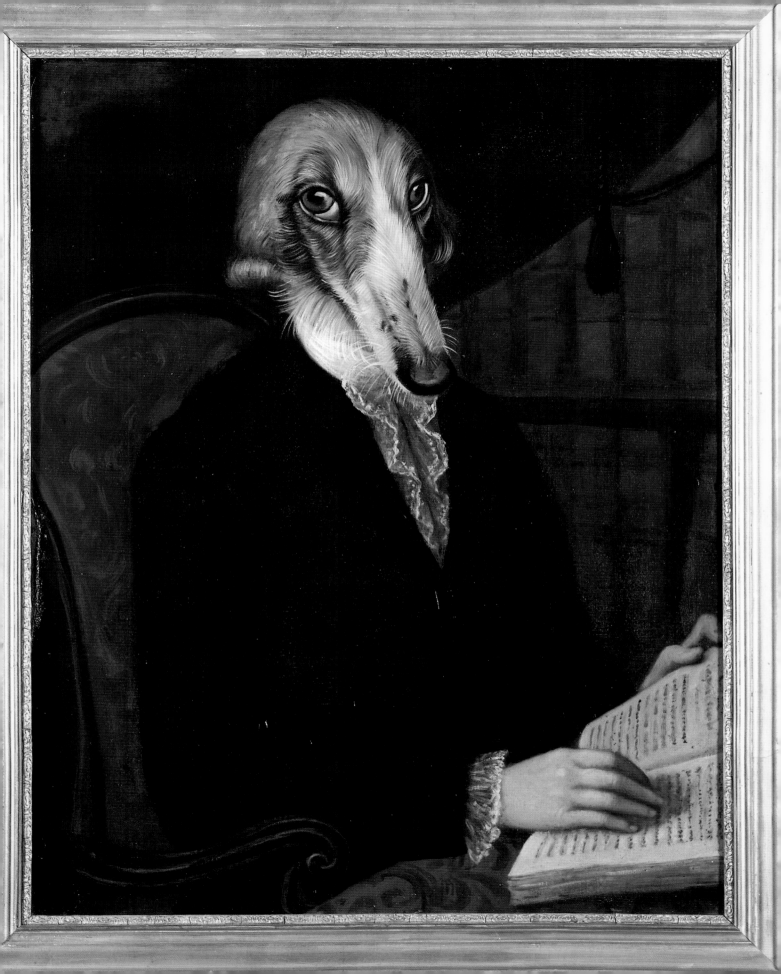

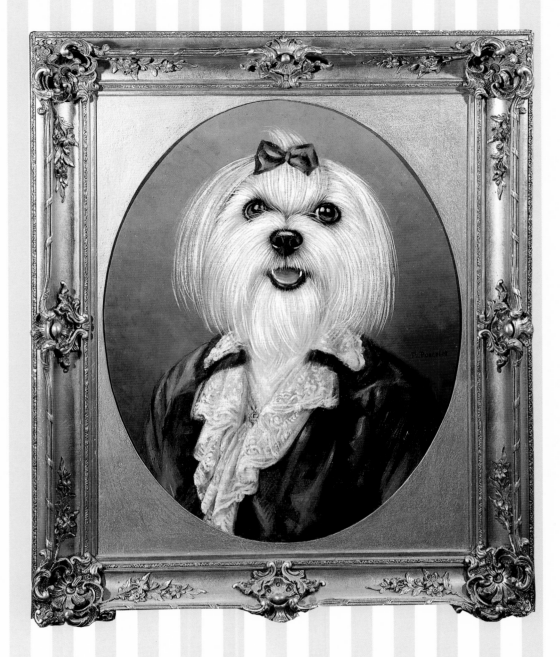

Babette Demalomar

She had chosen a soubrette's career, playing coquettish ladies' maids in the boudoir farces that so titillated Paris theater-goers in the 1880s. She had the look, the walk, and the talk down pat—but Babette's inborn compulsion to beg worked against the intricate *mise en scène*. She was fired every night. Yet the very trait that doomed her stage career led to spectacular success as chief fund-raiser for The Women's Aid Society.

Dolores Sanchez-Pellagroso

She was the most flamboyant courtesan of the age. Her look of dewy-eyed innocence could shift in a trice to a come-hither stare; scant wonder that her advent in the parks and other gathering places of Rome instantly drew mounting throngs of ardent admirers. And then she had what was called, simply, "the operation." Overnight, fiery courtesan had become placid homebody.

Chevalier de Saint-Denis

A man of delicate mien—though vicious *bonhomie*—Saint-Denis had a penchant for foreign affairs. Likened here in a more secluded repose without his famed turban, the Chevalier, after a langorous stint in the French cavalry, spent his days devoted to notions of Turkish leisure amidst a cadre of sultans in silk. Their evening proclivities, on the other hand, were said to be thoroughly Greek.

Fanny Dupuis

For a dazzling moment in time the artists' model Fanny Dupuis was the French toast of Paris: Queen of the Watercolorists' Ball; inspiration for DeClasse's monumental sculpture, *Viniculture Confronted by Blight*; serial inamorata of the occupant of every atelier on the Left and Right Banks. Then her legs stiffened, her teeth went, deafness descended, and incontinence. She snared an elderly butcher and retired into an obscure, but well-fed, senescence.

Annie Laurie MacNutt

Her Glasgow alehouse, The Wee Cur, was famous for its fistfights and Scotland's freshest lamb pies and mutton chops. The tireless Annie Laurie roamed the sheep meadows by day in search of fare for the evening meals to serve her boisterous but loyal clientele. "A glag and gallie yon muckle Annie," penned Robert Burns by way of singing her praises.

Zuzu

The Little Toy of Picardy thrilled patrons of Montmartre's smoky boîtes with her tremulous soprano rasp, her songs of constant hunger and the ravenousness of her need for love and comfort and kindness.

Dogs of War

General Sir Rex Clagg-Ponsonby

Fame came literally overnight to Clagg-Ponsonby. Heading a punitive Army expedition into the Afghan wilds to seek out and roundly scold the wily Wazu of Fluoristan, he came within half a mile of the Wazu's fortress before making camp—then recklessly pitched his own tent under its very battlements. Came morning and the Wazu meekly acceded to the British hiding: strange, unworldly noises in the night had convinced him that the Divine One was angry and that he must make amends. Later, serving in the House of Lords, Clagg-Ponsonby made history again. He became the first member ever unseated for excessive snoring.

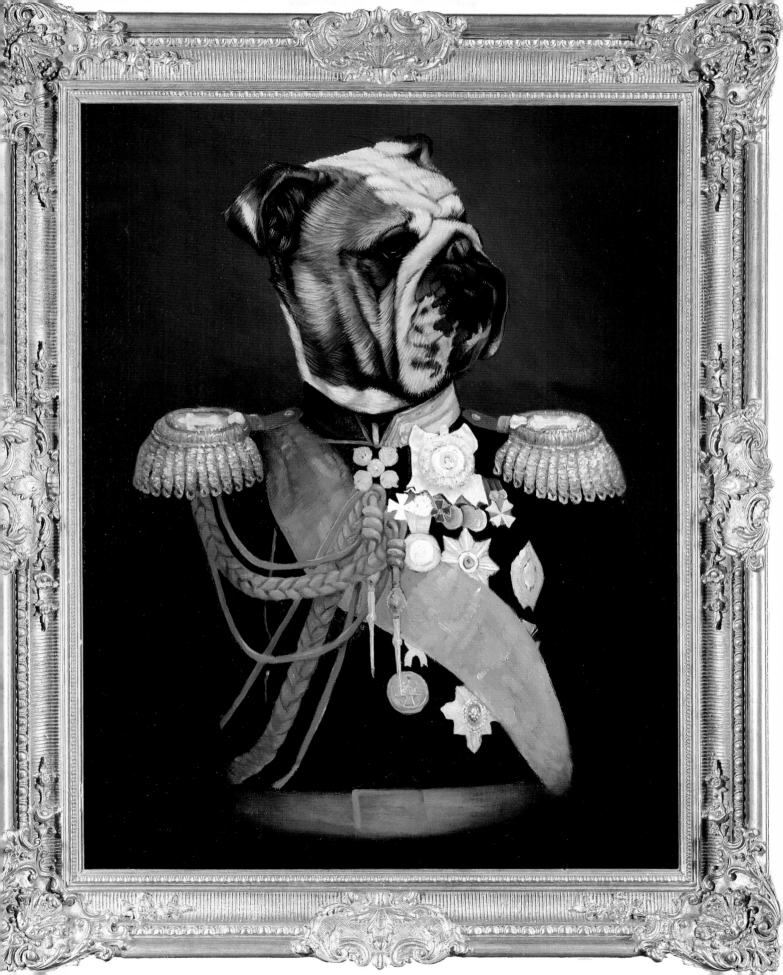

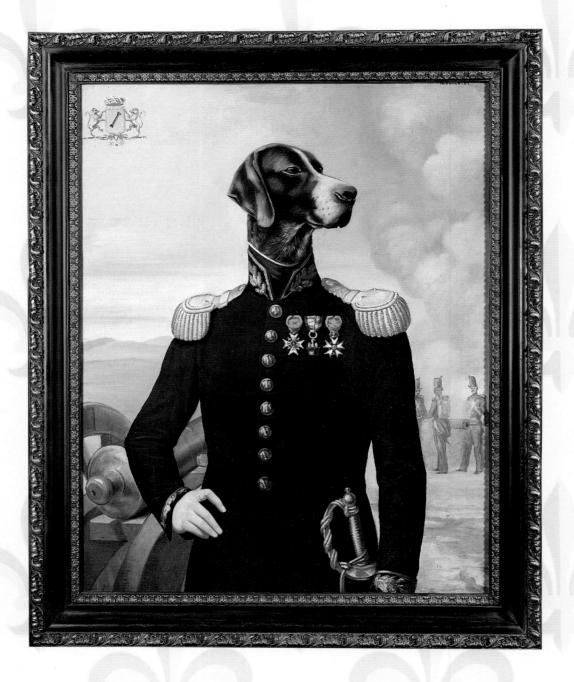

Graf Ludwig von Hespeler zu Galt

Wink at that correct Prussian bearing, aquiver at the scent of action; music was the young Ludwig's life. It was his elite Clavichord Corps that led the Leipzig Guards into the Battle of Boffo. Not grapeshot and saber thrust but the lacy, ethereal strains of Mozart would disarm the foe. Alas, instead of a musical blitz, cannon balls rained.

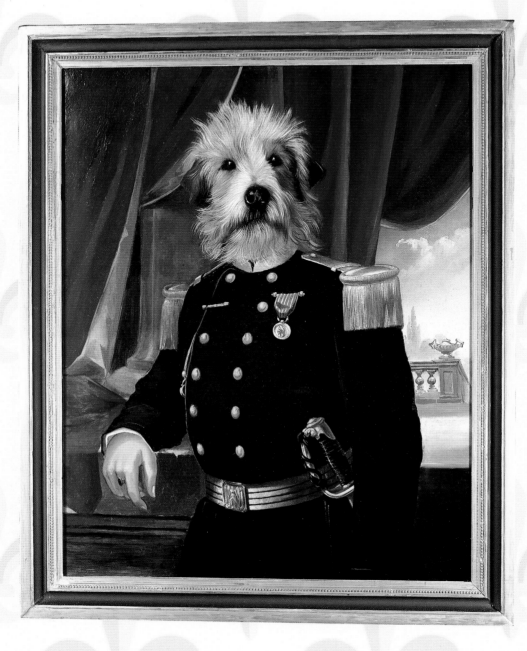

Rear Admiral Oswald Brabant

*B*rabant, a salty old dog indeed and the very picture of a
nineteenth-century sea lord, lent great distinction to his post
as Commander of the Royal Belgian Navy—or almost surely would have, had
Belgium had a Navy. But the willing and eager Brabant had long been a special pet
of King Leopold's, providing constant undemanding companionship, and all the high
Army posts that might have represented a worthy reward were already filled.

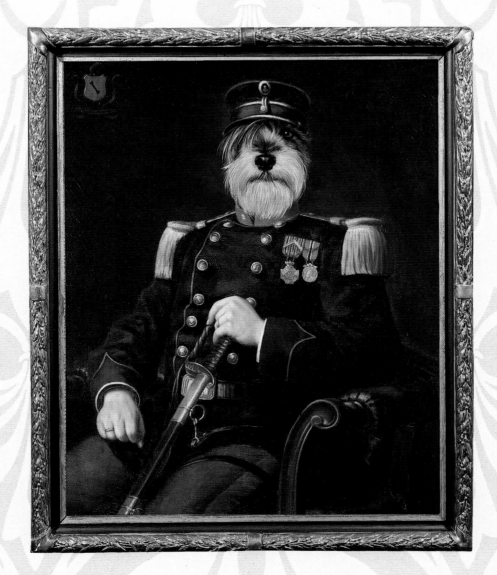

Major General Otto von Schnauzer

The Czar's favorite general was all nerve and no fear: leading his
Cossacks into the Battle of Fadoka by having himself shot from
a cannon into the French line, von Schnauzer earned victory and a
permanent stagger. The war stories he loved to tell on his tireless post-
retirement bar-hopping forays suffered from a certain lack of atmosphere.
"There we were in the pitch dark, fifty feet inside the enemy lines…"
he would begin—but almost never finish, for want of listeners.

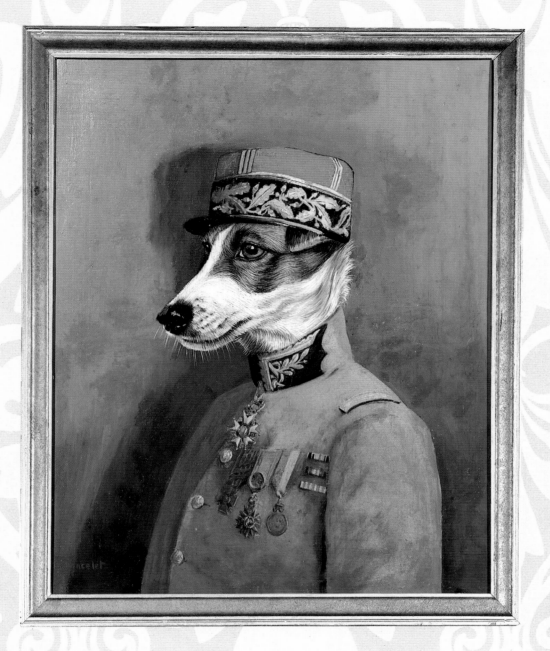

Maréchal Hector Defechereux

His beginnings were unpromising. Raised on a humble farm in the Jura, forced to sleep outdoors and eat scraps from a bowl, the young Hector Defechereux ran away from home and threw in his lot with the Army. Within a decade he was Maréchal Defechereux, conqueror of Morocco and Algeria. *"Hal al Halla!"* warned his Arab adversaries. "Beware the Dog!" The Maréchal was for all his ferocity a gallant and a ladies' man; North Africa today is heavily populated by descendants of his offspring.